SCOTLAND IN PHOTOGRAPHS

SHAHBAZ MAJEED

AMBERLEY

First published 2017

Amberley Publishing
The Hill, Stroud
Gloucestershire, GL5 4EP

www.amberley-books.com

Copyright © Shahbaz Majeed, Frame Focus Capture Photography, 2017

ISBN 978 1 4456 6621 1 (print)
ISBN 978 1 4456 6622 8 (ebook)

British Library Cataloguing in Publication Data.
A catalogue record for this book is available from the British Library.

Origination by Amberley Publishing.
Printed in the UK.

FOREWORD BY BRIAN COX

Every self-respecting Scot comes over all proprietorial when introducing the glories of their country to a friend or loved one for the first time. And we Scots have every right to be proud. When the rain stops falling and the mist clears, there is no more beautiful place on Earth.

This fine collection of photographs from the award-winning young photographer Shahbaz Majeed captures perfectly the unique visual gifts of my homeland, from the majesty of Glen Coe and the drama of the Isle of Skye to the scenic splendour of Perthshire's lochs and glens and rugged beauty of the North East coast.

Looking through these images makes my heart ache to return home and reacquaint myself with these special places.

Image: supplied

ACKNOWLEDGEMENTS

This book would not have been possible without the support of my family and especially my wife, Shazia, and my dad, Abdul, always encouraging and supporting me. Many a time I have spent days away pursuing my passion (or obsession if you will) and my wife has always been understanding. This book is evidence for her that I have not just been parked down the road having a nap in the car.

My dad, who is extremely proud of my achievements, still doesn't understand why I go to the lengths I do to get these pictures but supports me anyway. Thanks Dad for everything – and yes, I will come round later and show you how to set the alarm on your phone, again.

My little girls, Aena and Aiza, are still young and so don't often understand the reasons for the time I spend away, but when they are older I hope this book will be a way for them to be a part of the journeys that they missed. That said, my older daughter has plenty of comments towards the images she sees, ranging from genius to downright strange. Some of my favourites, to name a few:

'Is that where the dinosaurs live?' [Trotternish Ridge, Isle of Skye]
'That's a silly place to leave your boat.' [Bowling Harbour, Clydebank]
'Daddy, why are the stars like that? Can't they spell my name?' [Abernyte]

I have a great deal of gratitude to all at Amberley Publishing but especially Alan Murphy for his professional guidance in producing this book and for choosing me to author this publication. You sir, are awesome.

To my friends, teachers and colleagues at the University of Dundee, my alma mater, for supporting me throughout my fantastic years as a student and then as a member of staff. I am very proud of having attended this great institution and while I may not be as famous as some of our other alumni, rest assured I am working on it!

Dundee Photographic Society (www.dps-online.co.uk) has played a large part in my photography. Joining the society was the best decision I ever made, as it gave me the opportunity to see a large variety of images from across the spectrum and especially from those that have been taking images for a long time. It really allowed me to learn a lot in a relatively short period of time and for that I will always be thankful.

Although too many to name, you all know who you are – from my friends and fans on social media, to those who have bought my work in some form or another or attended my training courses to improve your own photography. The marketing folk, the publishers/editors, image buyers that have used my work for everything from books to television, to billboards and currency, I am proud of every single feature.

Not forgetting all those that will come to know of me in the future – this is also for you! If you don't like my work for whatever reason, then this is obviously not for you. Not thanking the trolls, who sometimes comment 'I've lived there all my live and it looks nothing like that.' Life is too short. I hope one day you finally get the chance to see the world for the beauty that it is.

A heartfelt thank you to Brian Cox for writing the foreword and being associated with my book. I know how extraordinarily busy you are (especially during the time when this book was being put together) but you managed to make time for a fellow Dundonian. Your words towards my work are extremely humbling and I am extremely honoured to have had your support. Thanks also go to Brian's PA, Vanessa Green.

To all my fellow photographers – those that I know personally and those online – lets continue to inspire future generations and those around the world with our work.

For when my little girls are older, I hope you grow up appreciating your surroundings and enjoy these images as much as I enjoyed taking them – for your benefit as much as everyone else. One day you will finally find a way to make the stars spell out your name, of that I am certain.

ABOUT THE PHOTOGRAPHER

Shahbaz Majeed was born and raised in Dundee, Scotland, and has been taking pictures for almost ten years. Over the years he has won numerous competitions and awards for his work, at national and international levels in some of the biggest photography competitions attracting entries in the hundreds of thousands.

In 2011 he won the National Rail category of the Take A View Landscape Photographer of the Year competition and was a finalist in the National Geographic International Photography Contest. He also reached the final of the prestigious Hamdan International Photography Award (HIPA) 2013 competition in Dubai, which attracted entries from 38,000 photographers across the world, and has had images chosen as the Top 101 across the world. More recently, he has had his image chosen in the Top 50 out of 106,000 entries in the Sony World Photography Awards 2016. His images have been seen around the world, showcasing Scotland on an international platform.

Some of his clients include prestigious brands such as the V&A, VisitScotland and Microsoft, and he has had one of his images feature on UK currency: his image of the Forth Bridge has been used on the first polymer £5 note, launched in Scotland and the first of its kind in the UK, now a part of history.

Shahbaz's belief is that we as photographers have an important job, not just to document our surroundings but to share our work in order to promote the beauty of the world to others. By sharing our knowledge with others, not just to inspire future generations of photographers but to also push the boundaries and quality of our own work, we will inevitably raise the game for the better.

The images in the book have been taken on a variety of cameras and lenses and using various accessories, some of which are as follows:
Cameras: Canon 5D / Canon 5D Mk II / Canon 1-DX / Phase One IQ3 80 / Phase One IQ3 100
Lenses: Canon EF 11-24mm / Canon EF 24-70mm / Canon EF 24-105mm /
Canon EF 50mm / Canon EF 100-400mm / Schneider Kreuznach AFD 28mm / Schneider Kreuznach LS 35mm / Schneider Kreuznach LS 80mm / Schneider Kreuznach LS 240mm
Accessories: Gitzo Mountaineer Tripod / Lee Filters / Hitech-Formatt Filters

www.framefocuscapture.co.uk

Top right: © John Alexander
Bottom right: © Chris Ireland

INTRODUCTION

The images in this book have been taken across Scotland, from some very well-known locations, to some not so familiar. These images will hopefully show you why tourists are attracted to our shores from across the globe and also why photographers are repeatedly drawn to the landscape.

There is just something about this land, the place of my birth, the mystery/drama of it all that is quite hard to explain, even by those who have lived here their entire lives. Many often wonder why you would want to visit Scotland in the first place and yet their own question is answered when they see the images for themselves. Some still question if a place can be as dramatic as the images show – perhaps there is some manipulation in the images to make it appear so? But when they visit for themselves, they find it hard to leave and yearn for the day when they will get the chance to return.

It is not hard to see why Scotland is chosen as a backdrop for major Hollywood blockbusters, computer-animated films and even Bollywood storylines.

As for visiting many of the places you will see featured in the book, it is often like a different place each time you visit: the weather can be mild and gentle one minute and then stormy and threatening the next. Not all places can claim to offer all four seasons in the same day.

I hope you get inspired by the images in this book and that they make you want to visit these locations for yourself. My aim is to highlight the beauty and variety of Scotland's landscape, not just to those from abroad but also to those that live here and have yet to discover much of the truly breathtaking landscape we are fortunate to have right here on our own doorstep.

I will leave you with the words that I leave my audience with at the end of presentations to inspire them. These words summarise why I take photographs and why I feel the medium of photography is such a fascinating one, as it can allow you to connect with viewers on an emotional level, which can be very powerful and equally rewarding.

'If my images stir an emotion or memory and helps make that personal connection, whether it is a reminder of a loved one or inspires you to go see the beauty of the world around us for yourself, for me there is no greater result.'

COAST

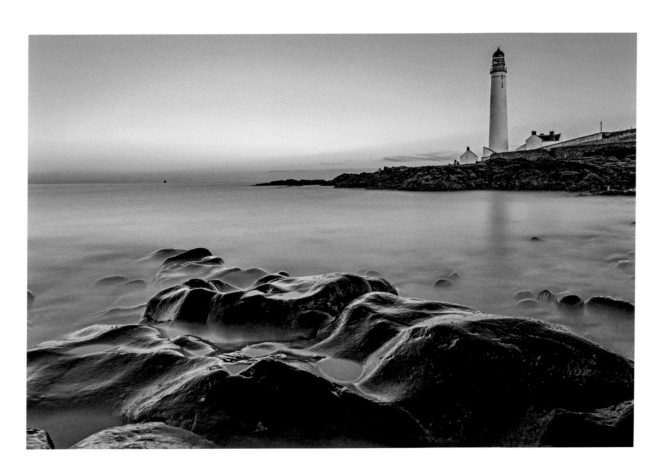

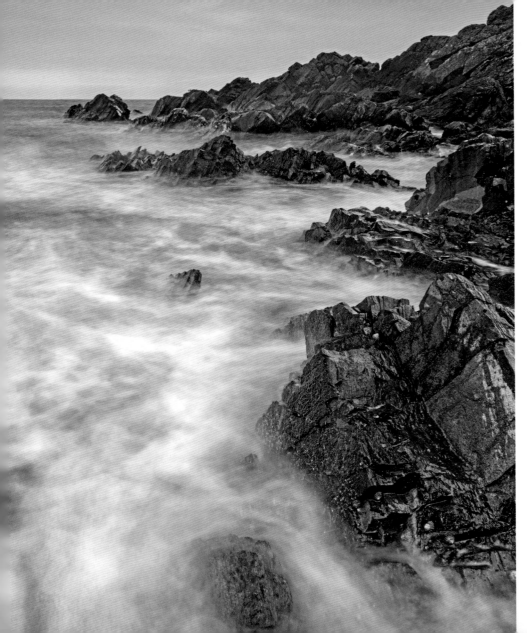

Skatie Shore

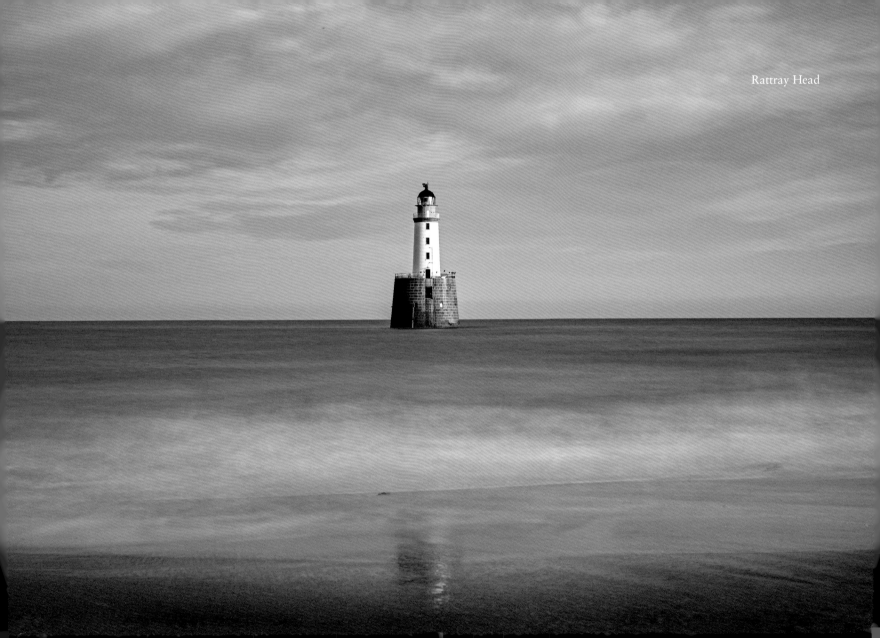

Rattray Head

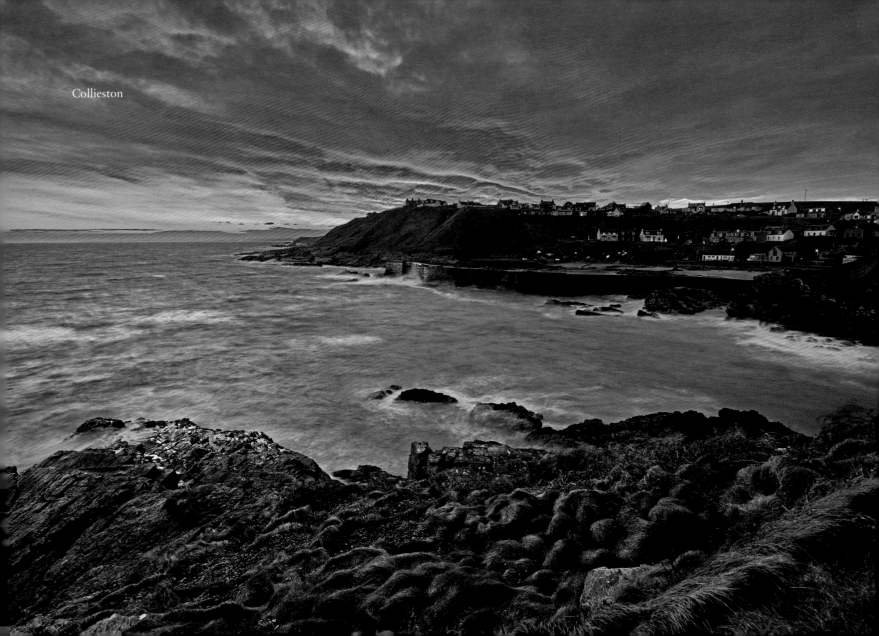

Collieston

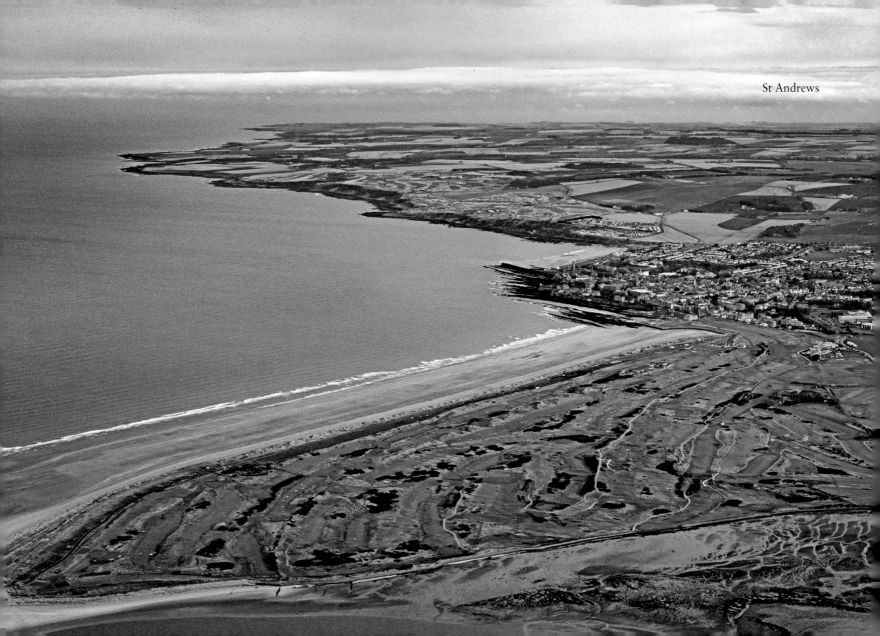

St Andrews

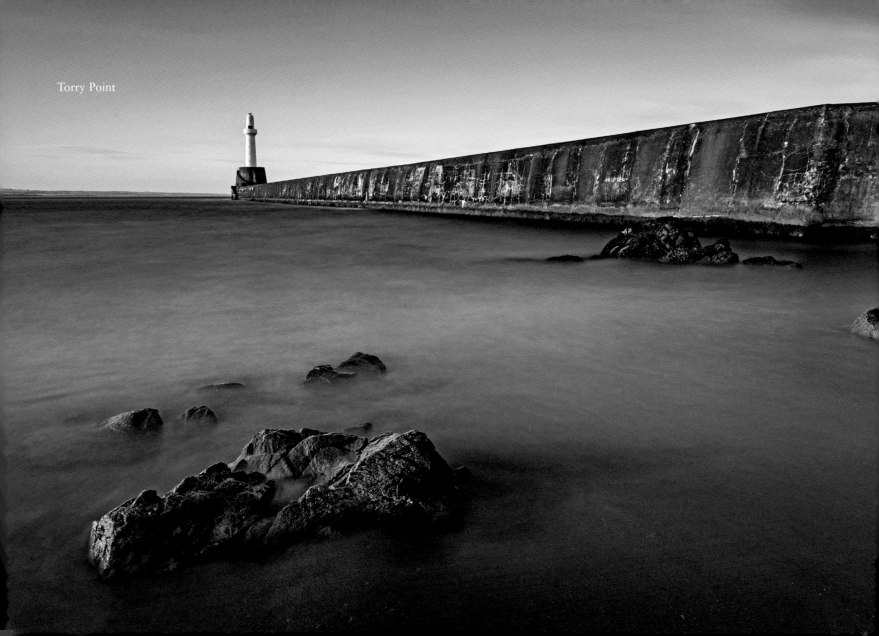

Torry Point

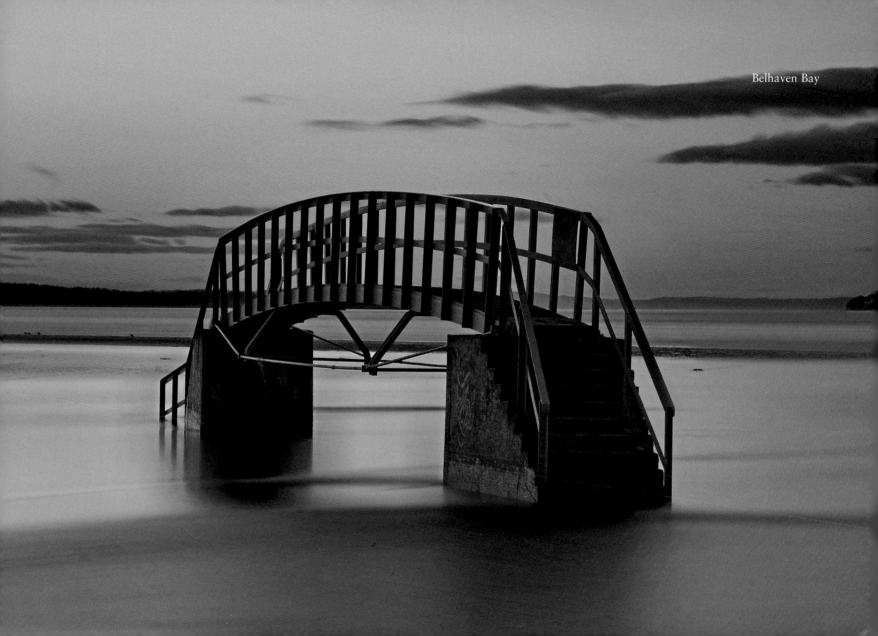

Belhaven Bay

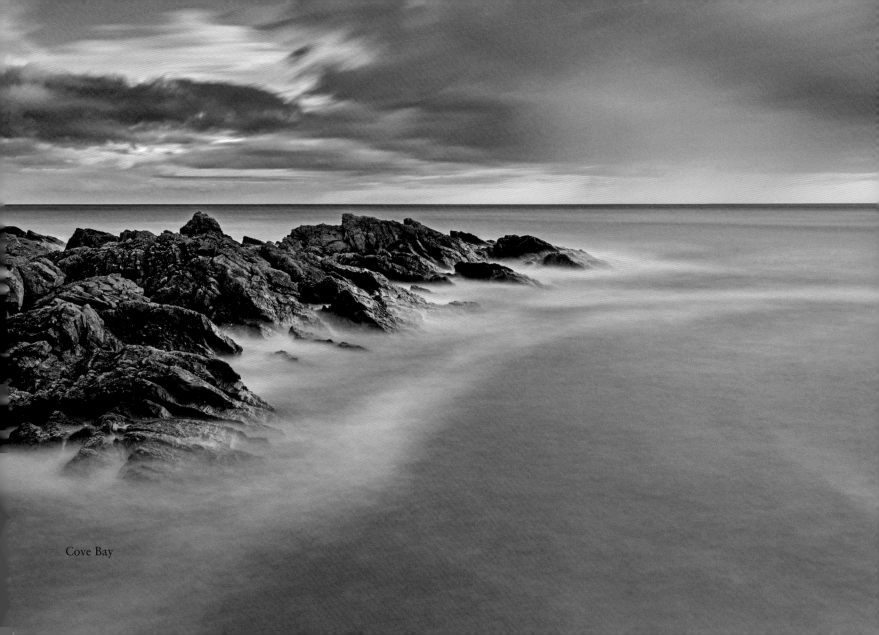

Cove Bay

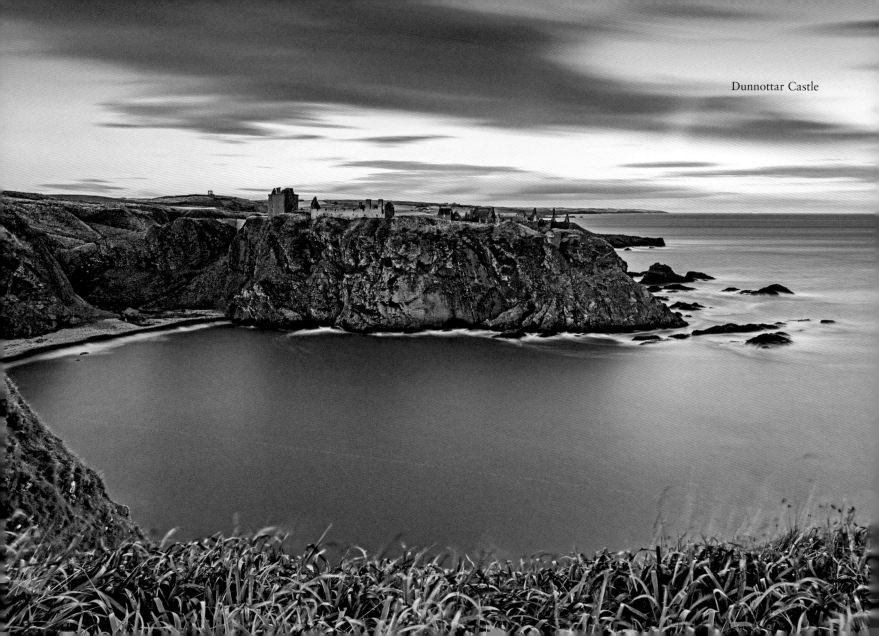

Dunnottar Castle

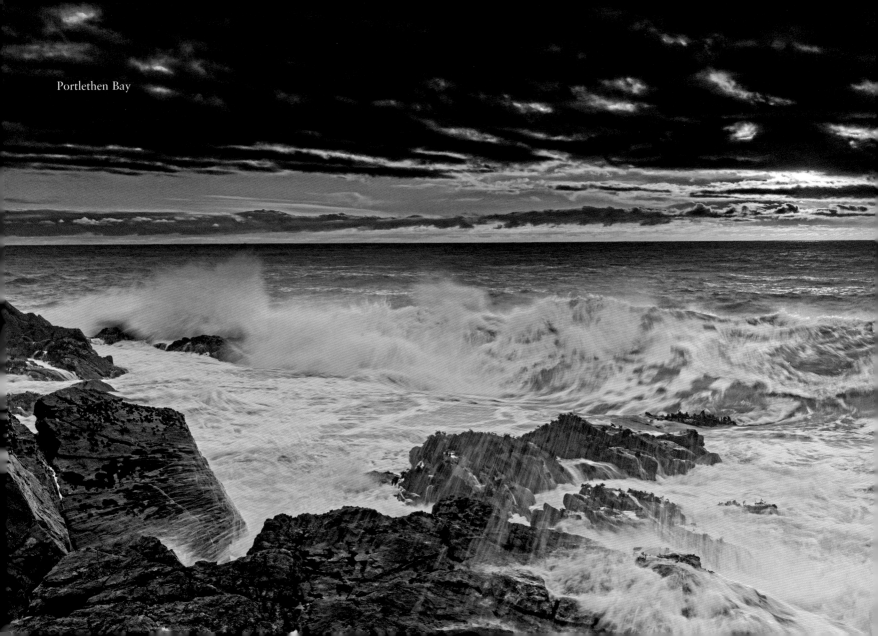

Portlethen Bay

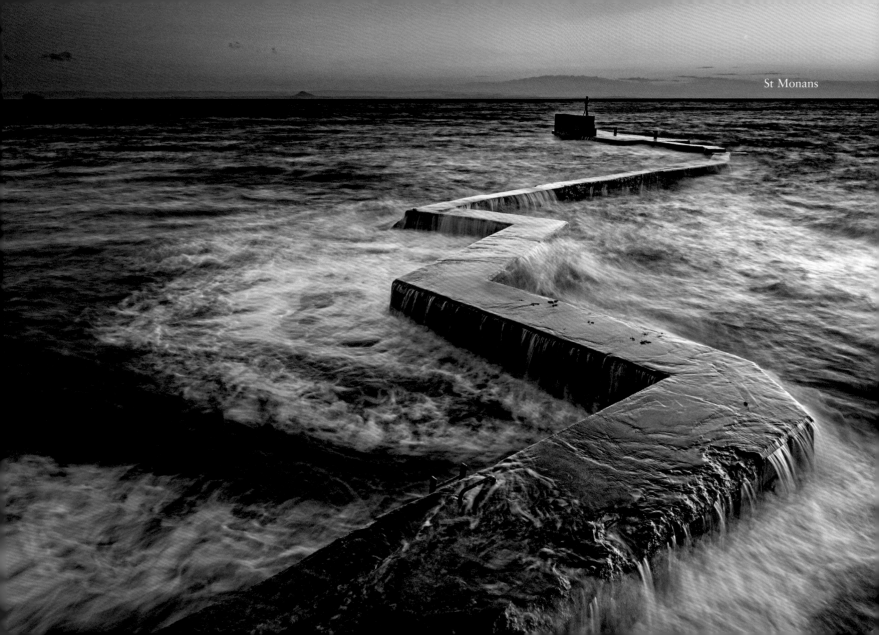

St Monans

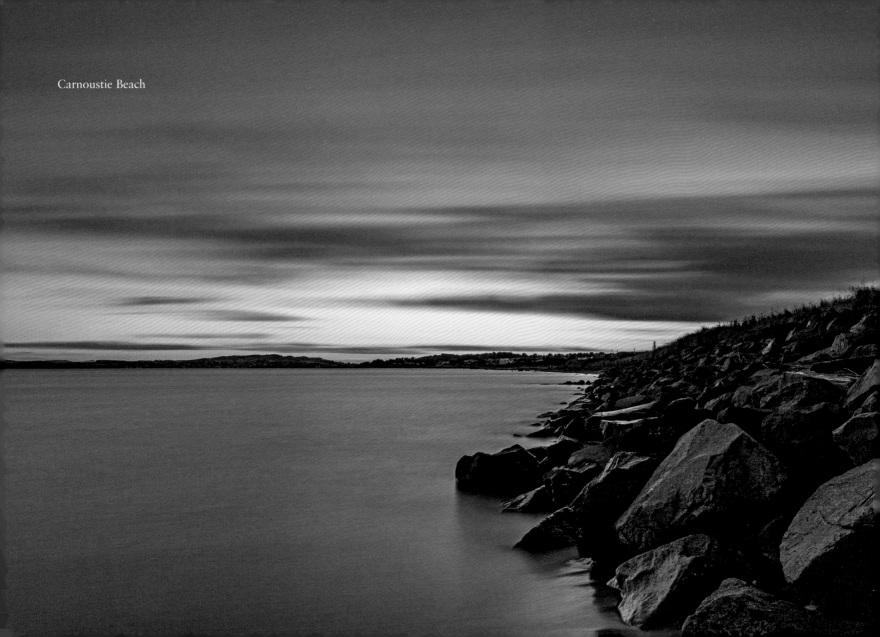

Carnoustie Beach

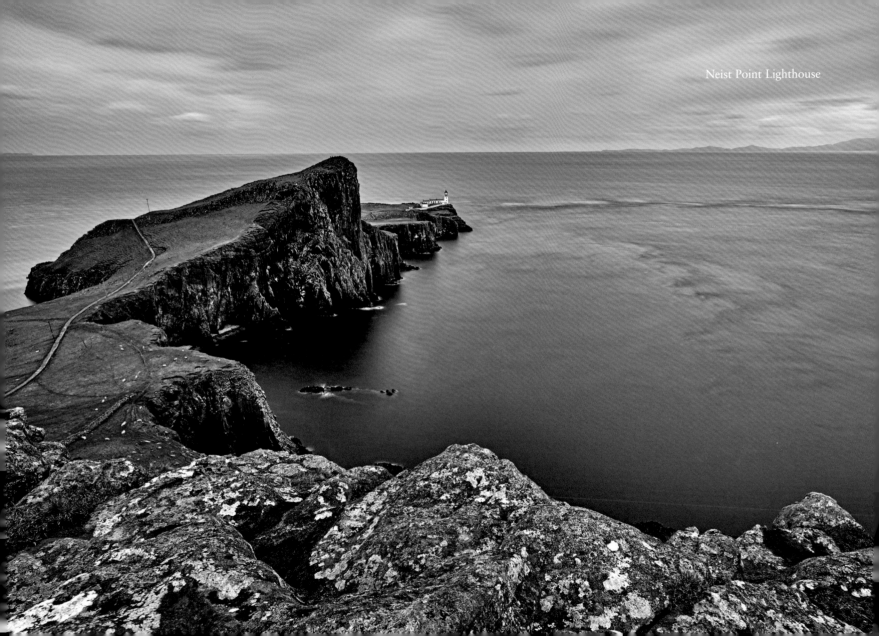

Neist Point Lighthouse

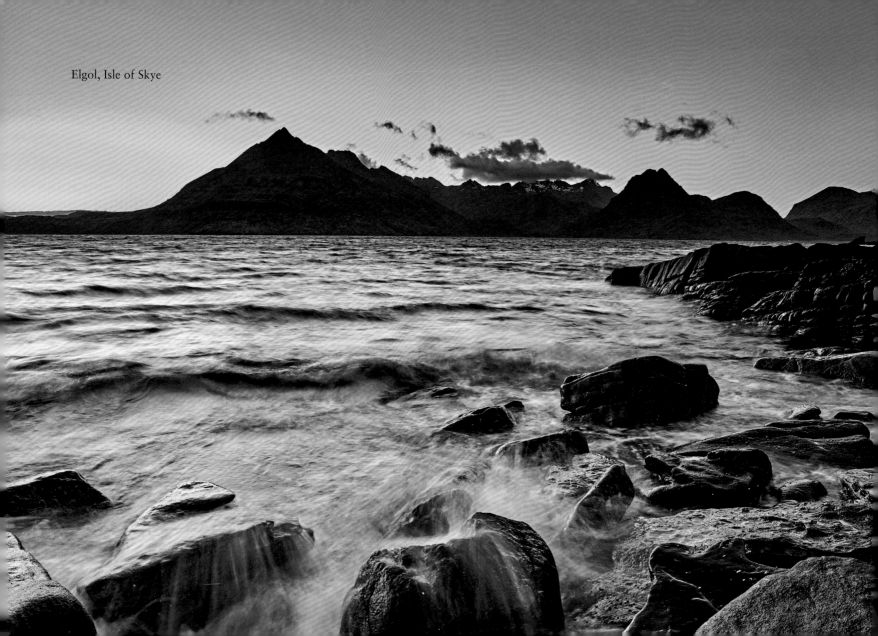

Elgol, Isle of Skye

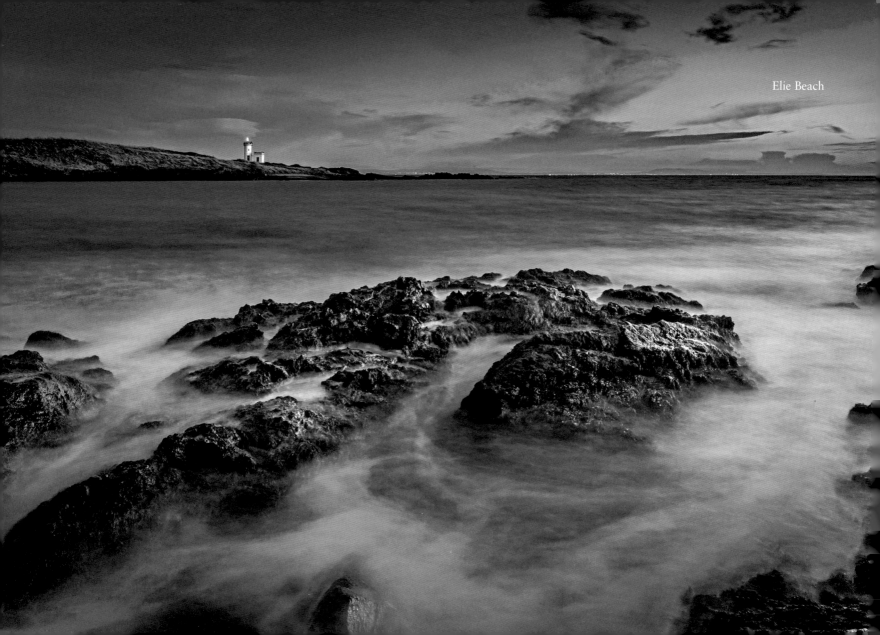

Elie Beach

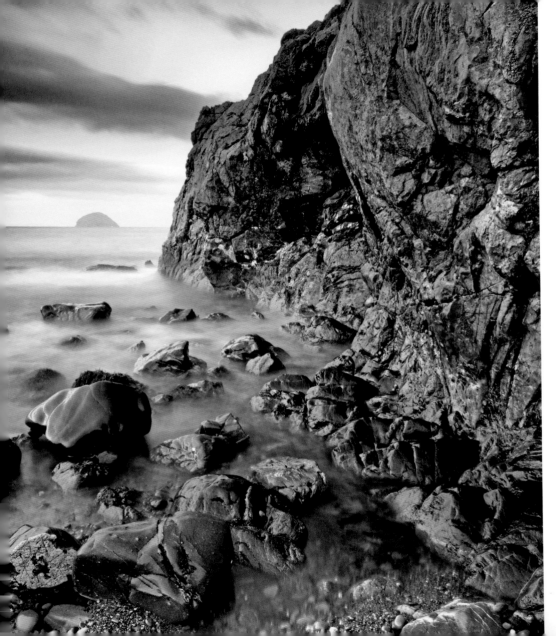

Girvan

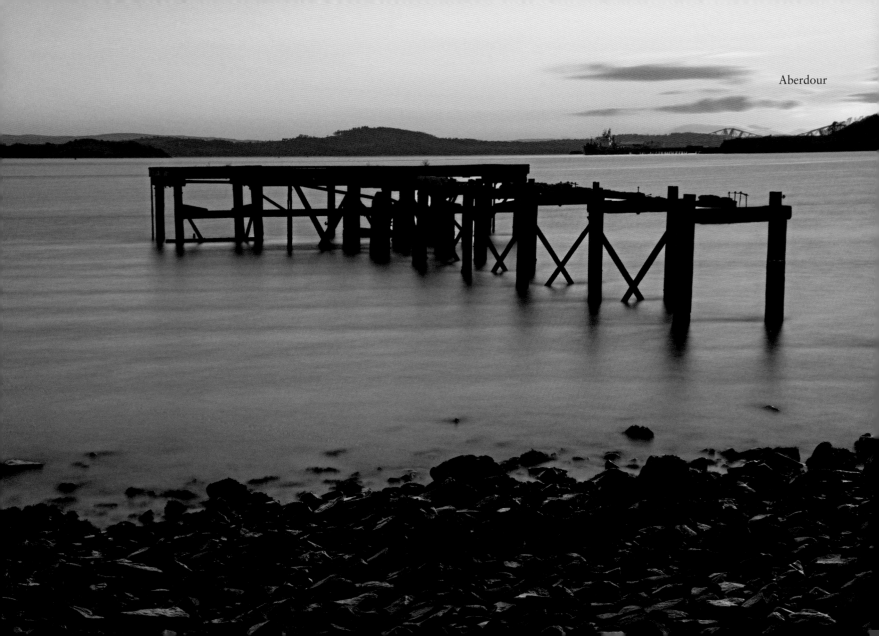

Aberdour

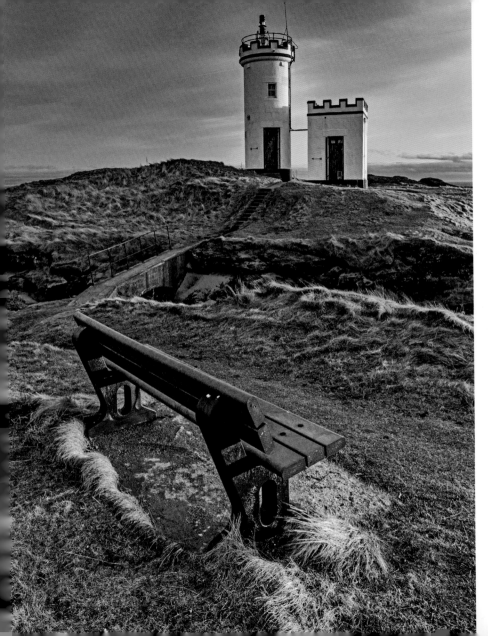

Elie Lighthouse

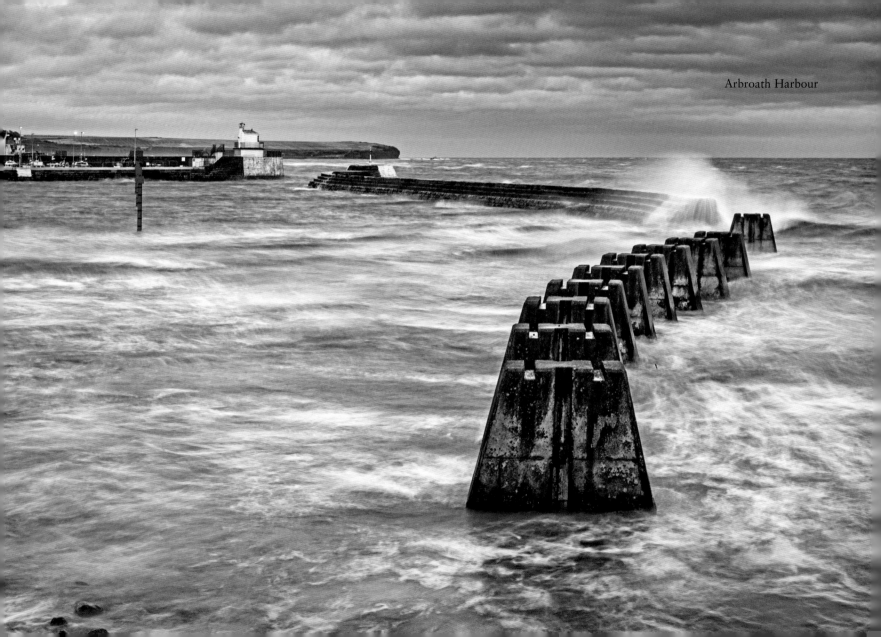

Arbroath Harbour

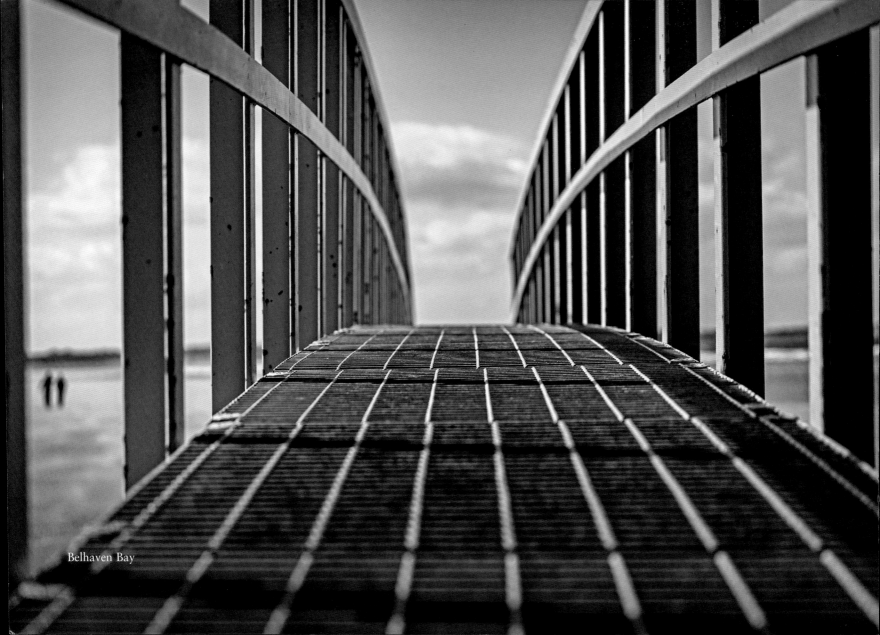

Belhaven Bay

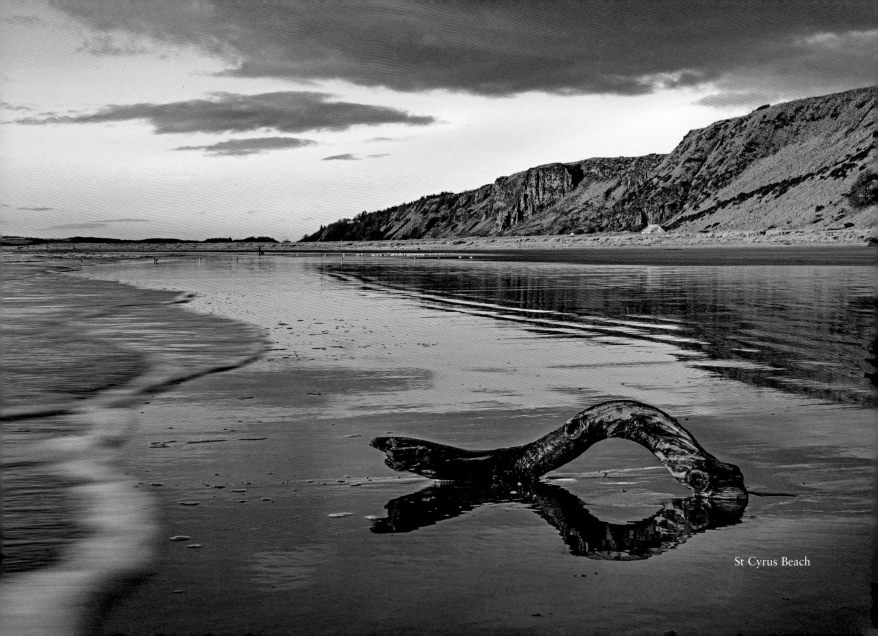

St Cyrus Beach

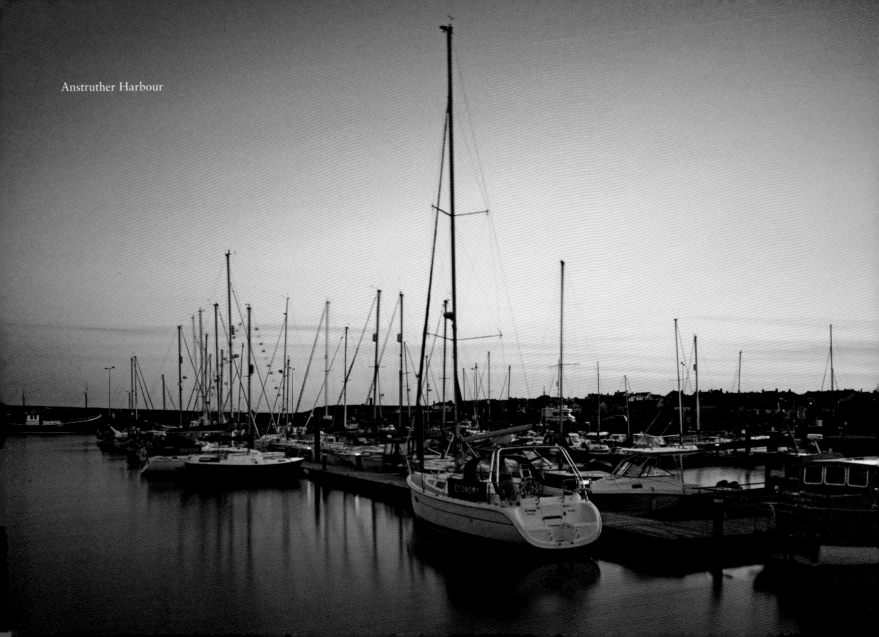

Anstruther Harbour

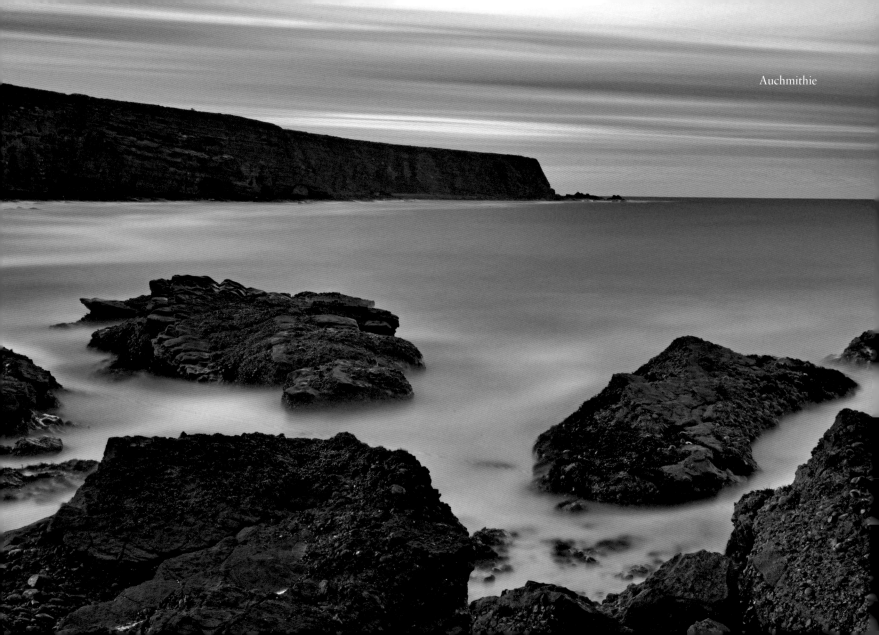

Auchmithie

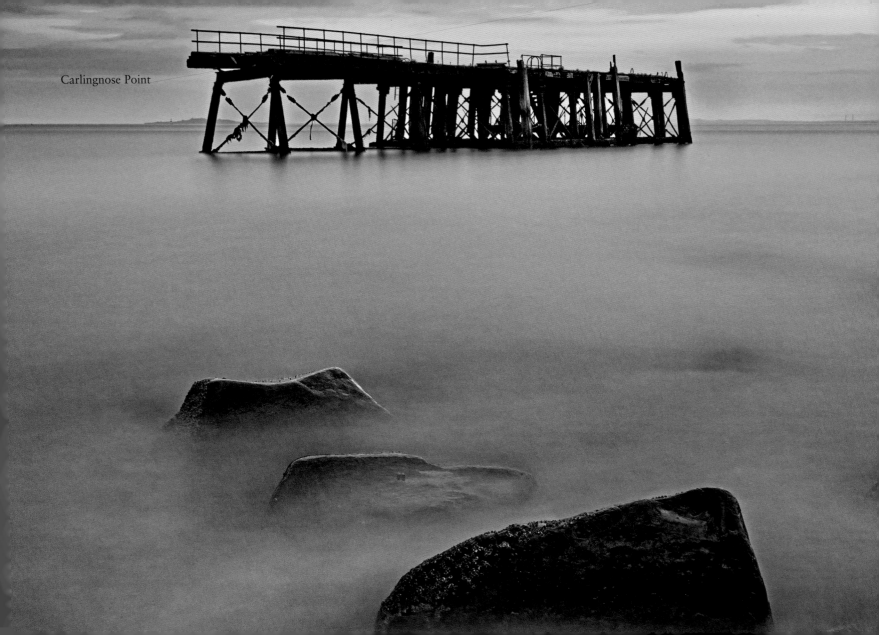

Carlingnose Point

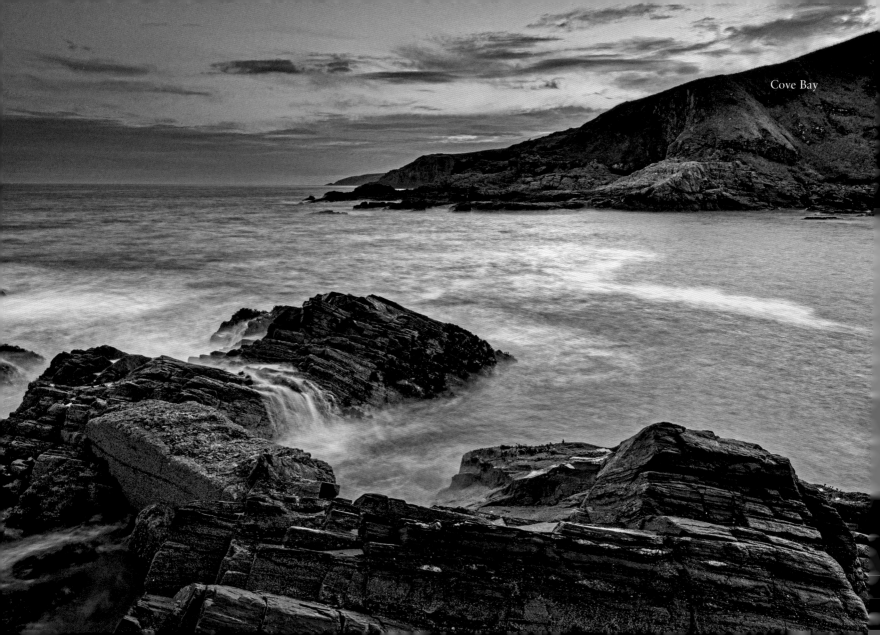

Cove Bay

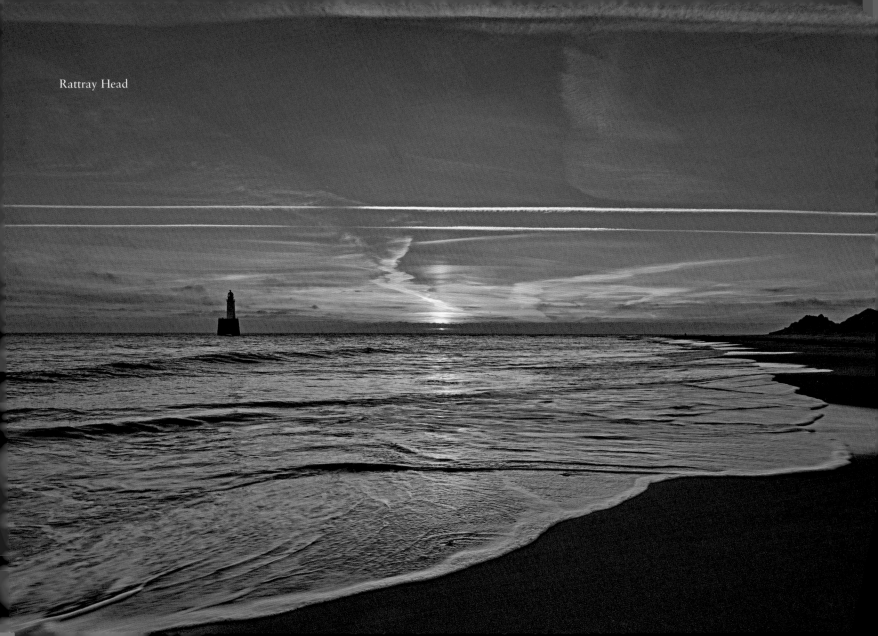

Rattray Head

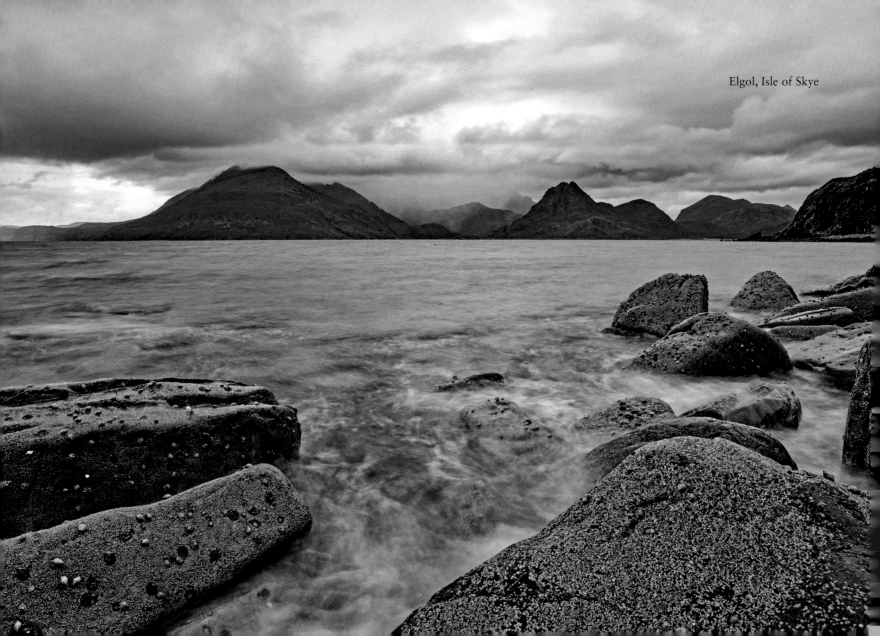
Elgol, Isle of Skye

LOCHS & RESERVOIRS

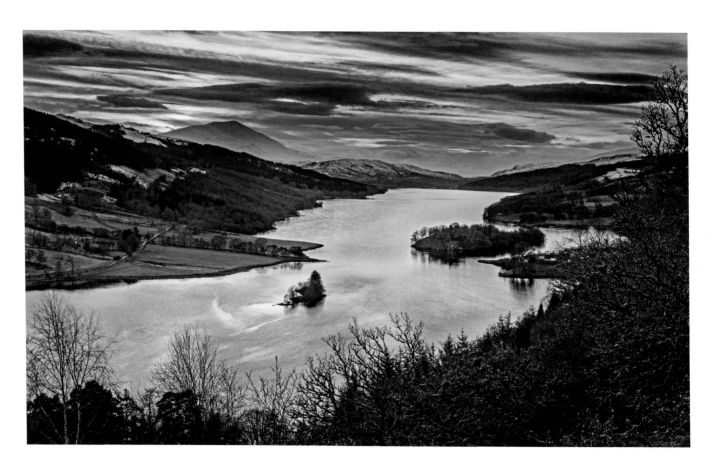

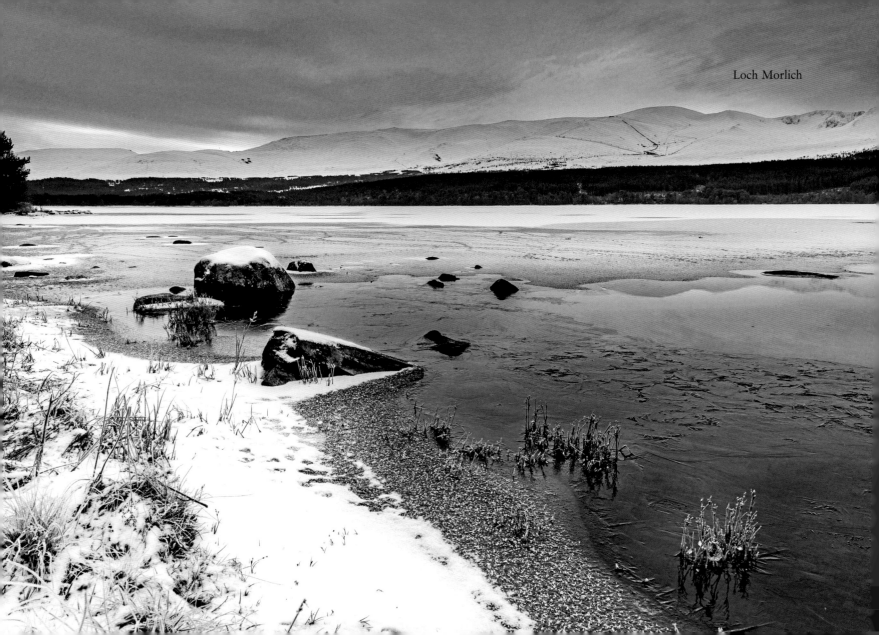

Loch Morlich

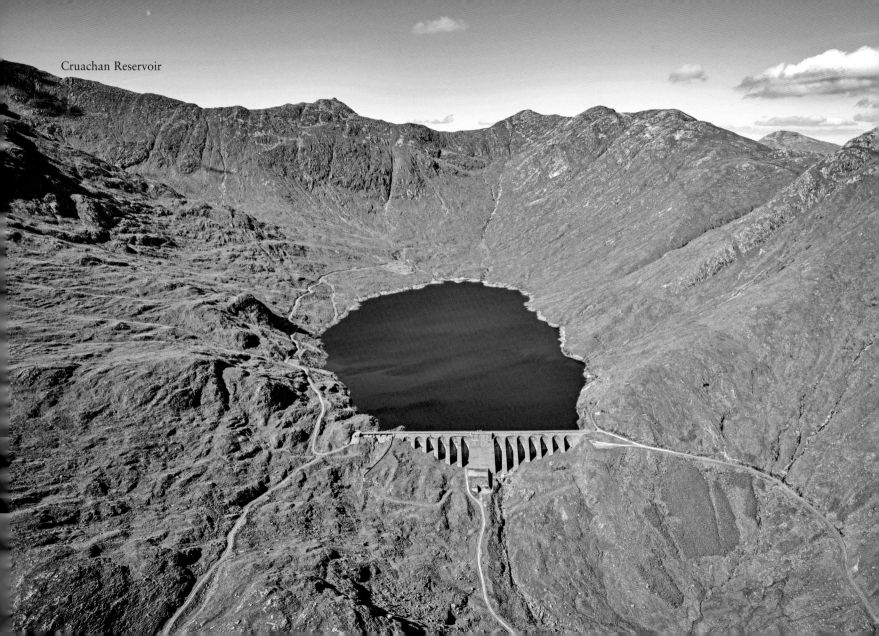

Cruachan Reservoir

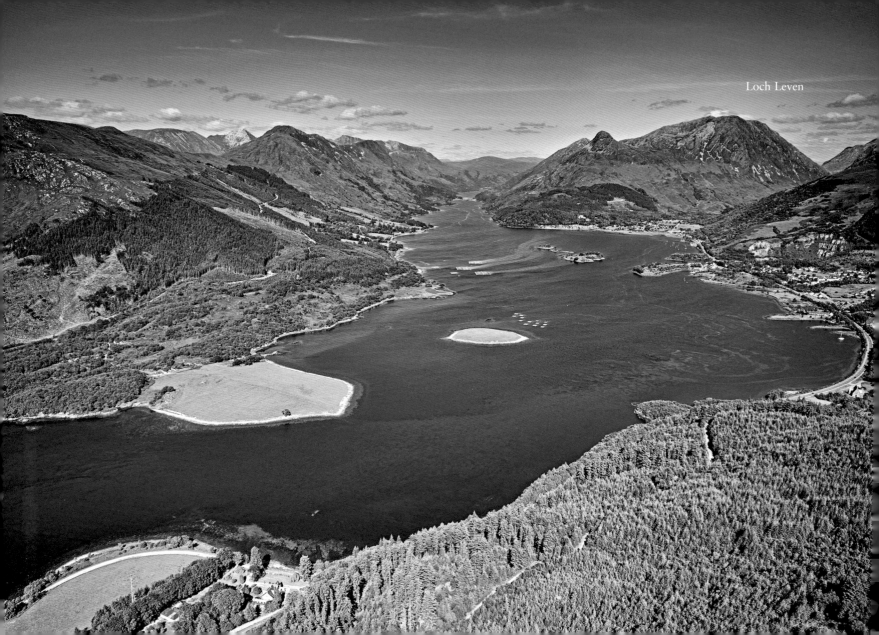

Loch Leven

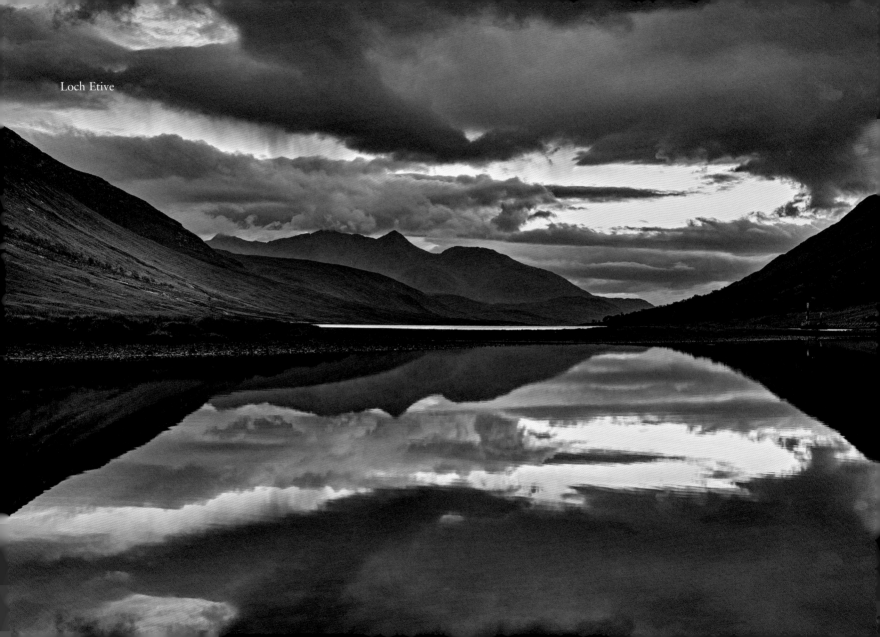

Loch Etive

Loch Lomond

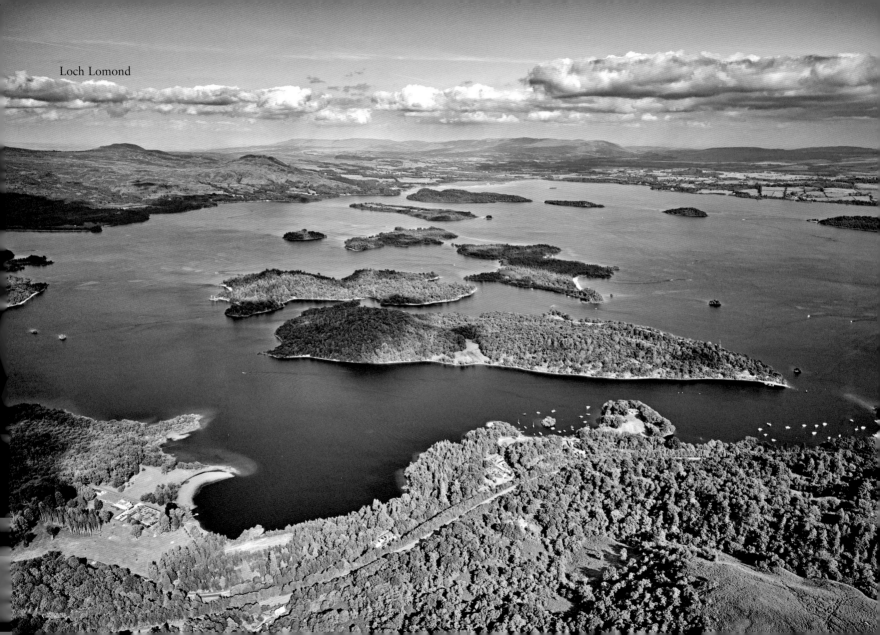

Loch Lomond

Loch Earn

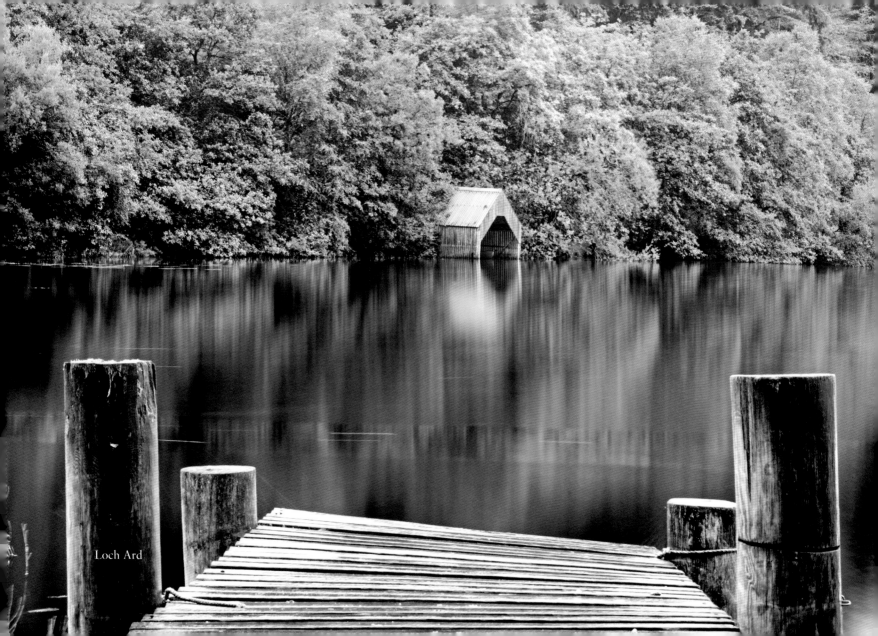

Loch Ard

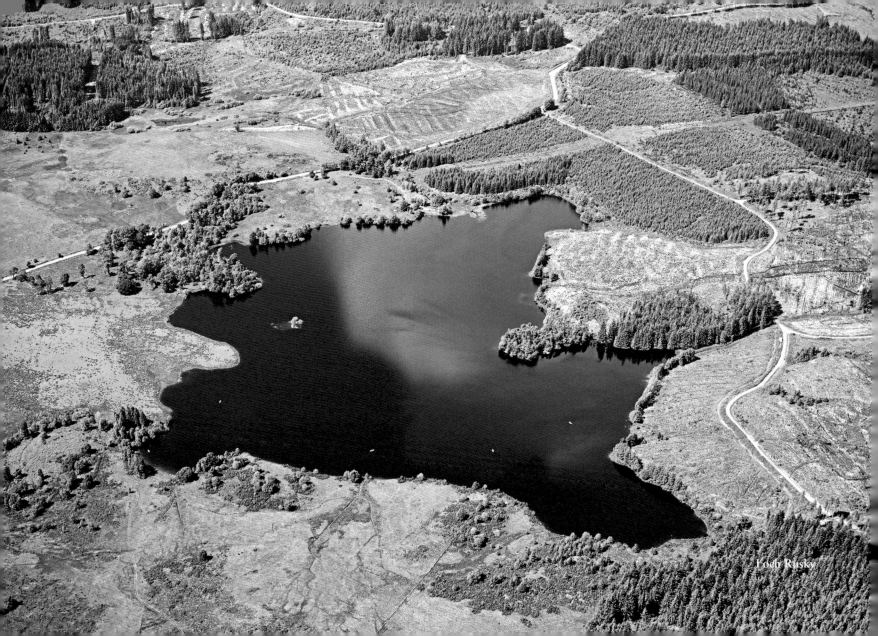

Loch Rusky

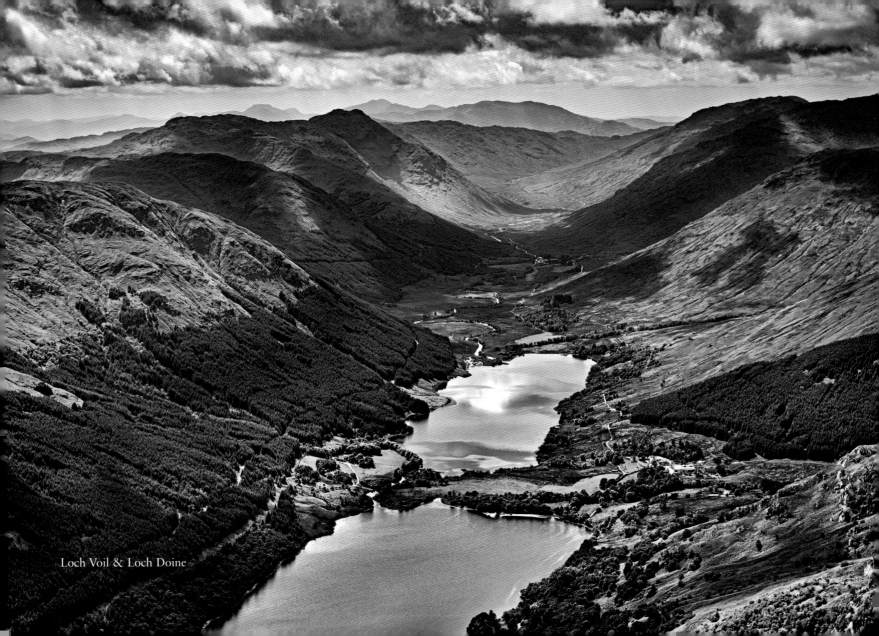

Loch Voil & Loch Doine

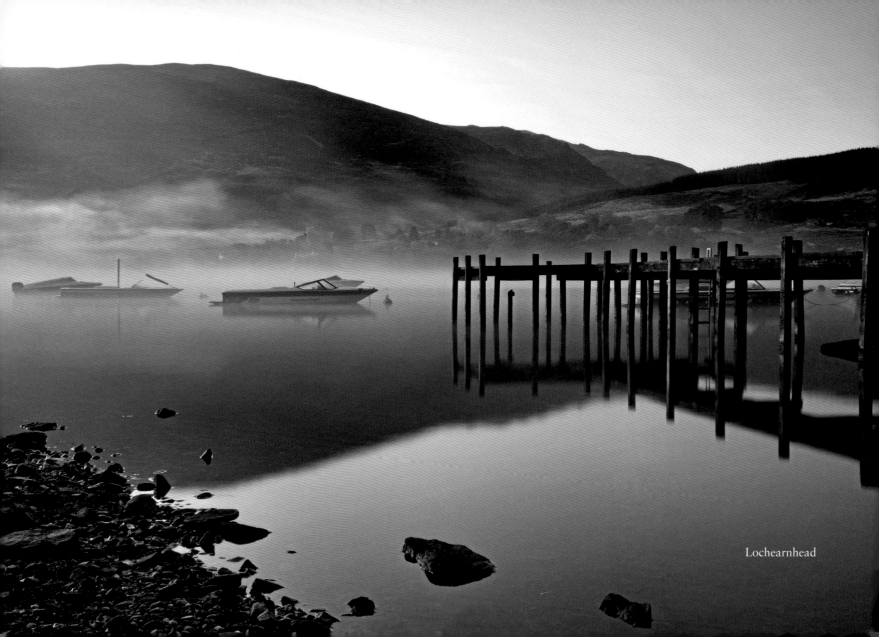

Lochearnhead

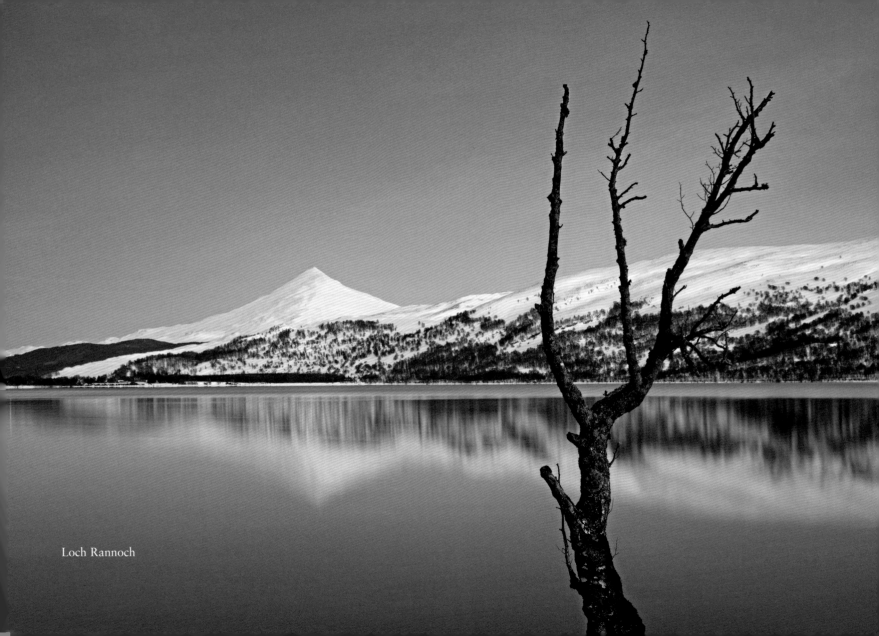

Loch Rannoch

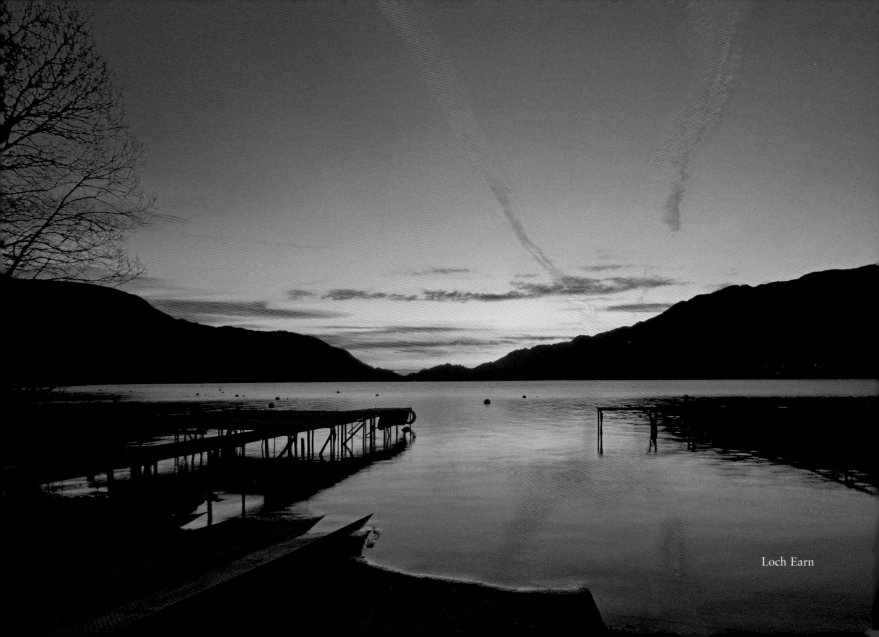

Loch Earn

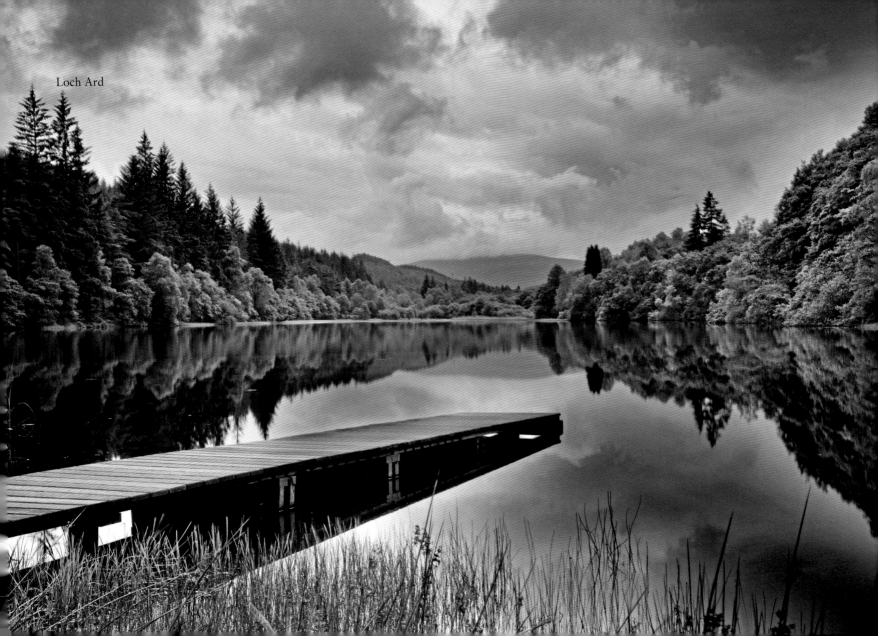

Loch Ard

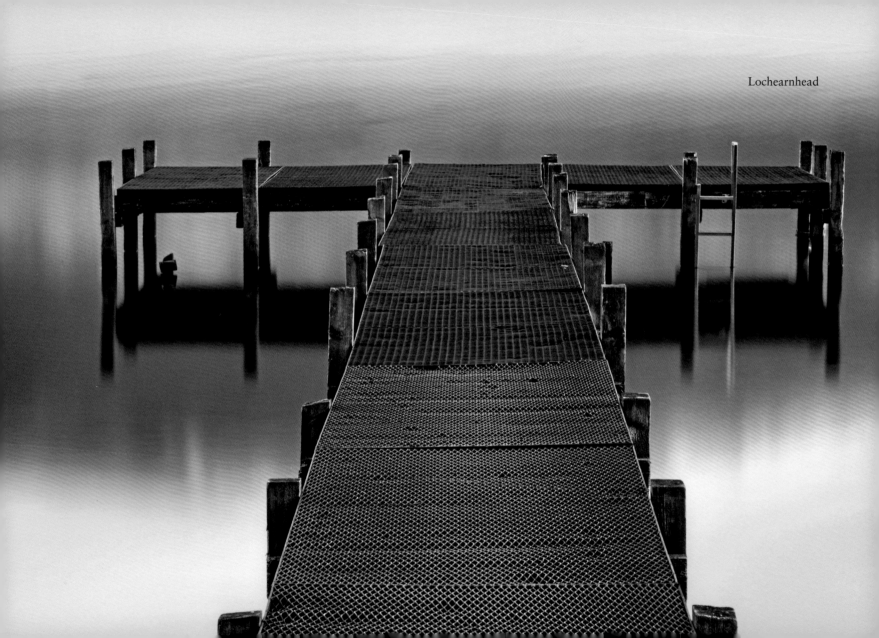

Lochearnhead

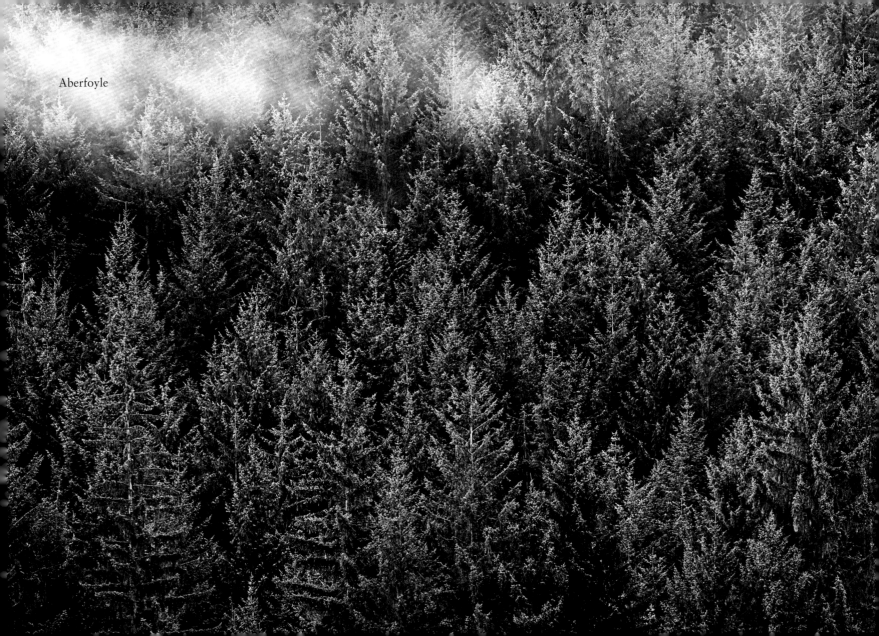

Aberfoyle

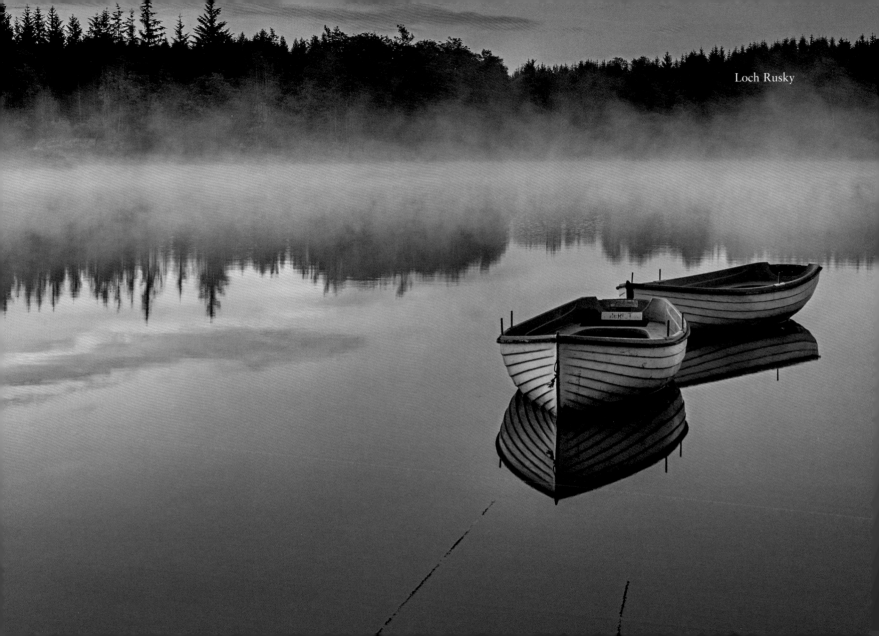

Loch Rusky

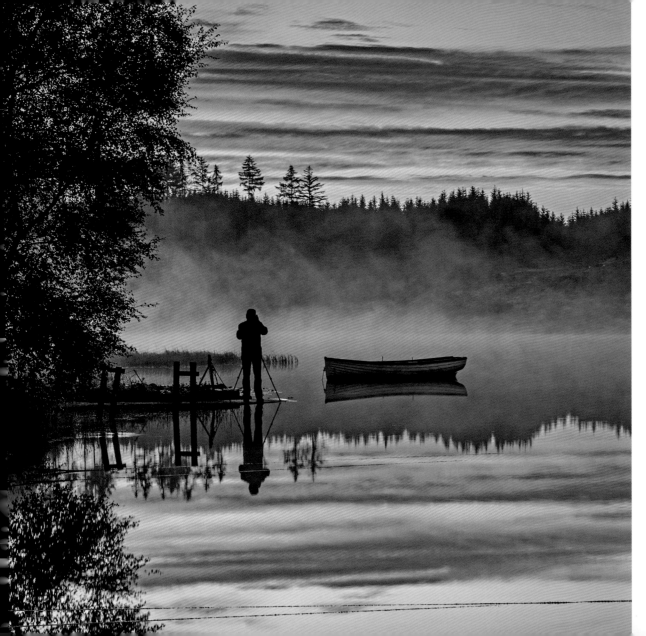

Loch Rusky

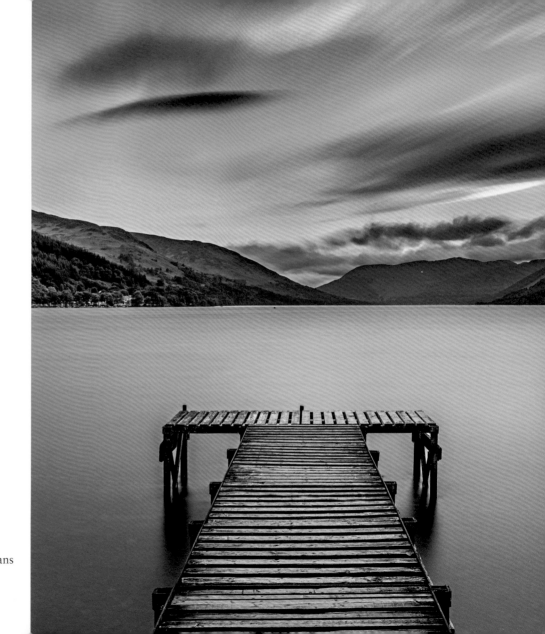

St Fillans

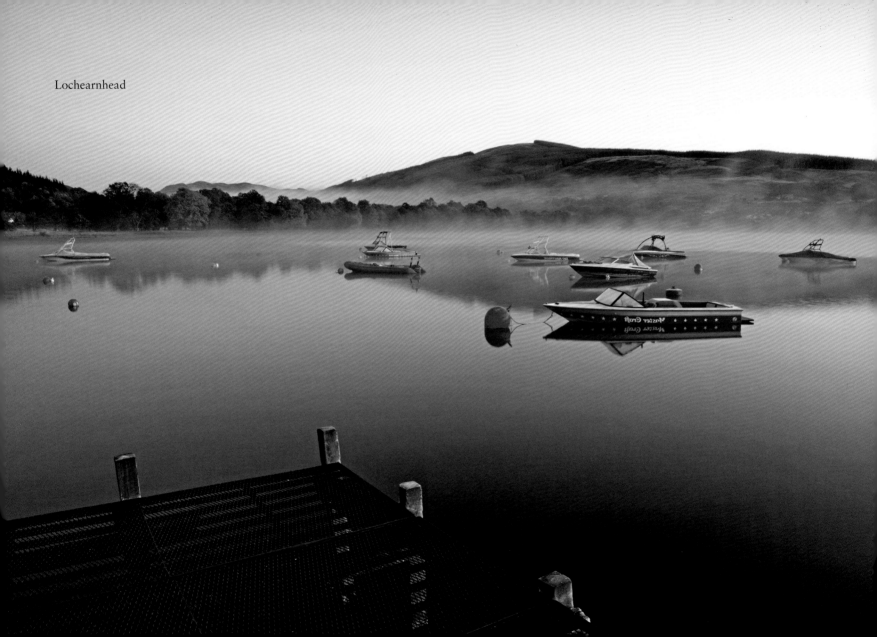

Lochearnhead

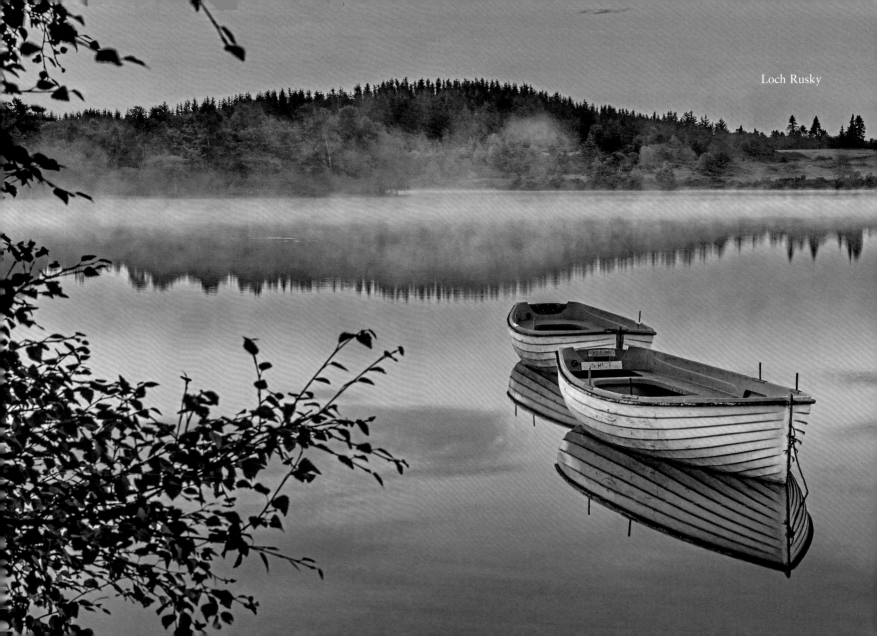

Loch Rusky

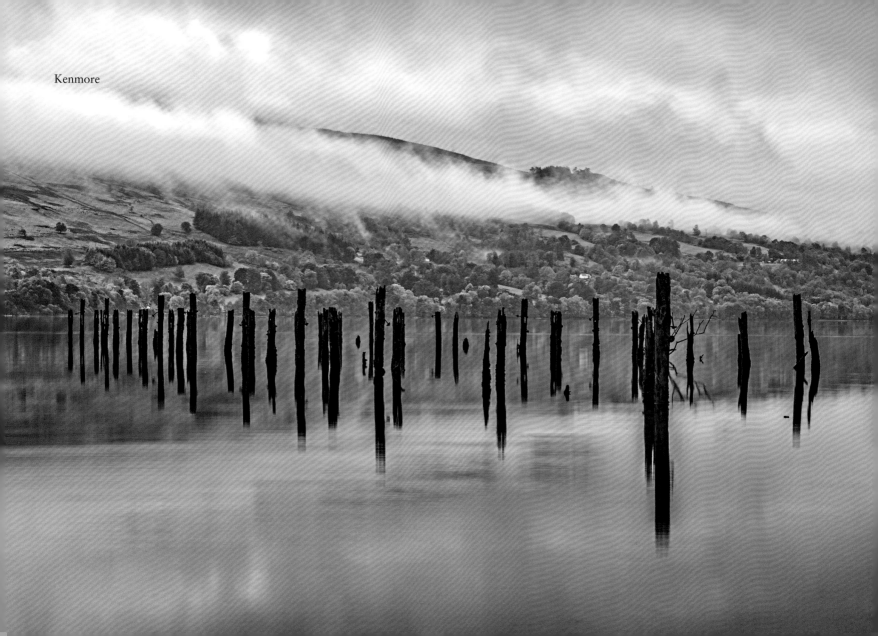

Kenmore

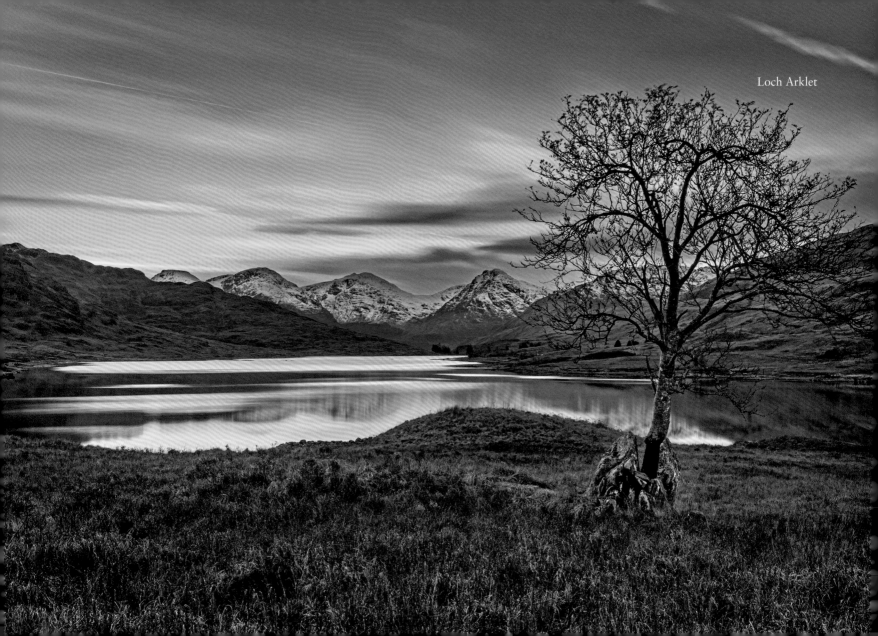

Loch Arklet

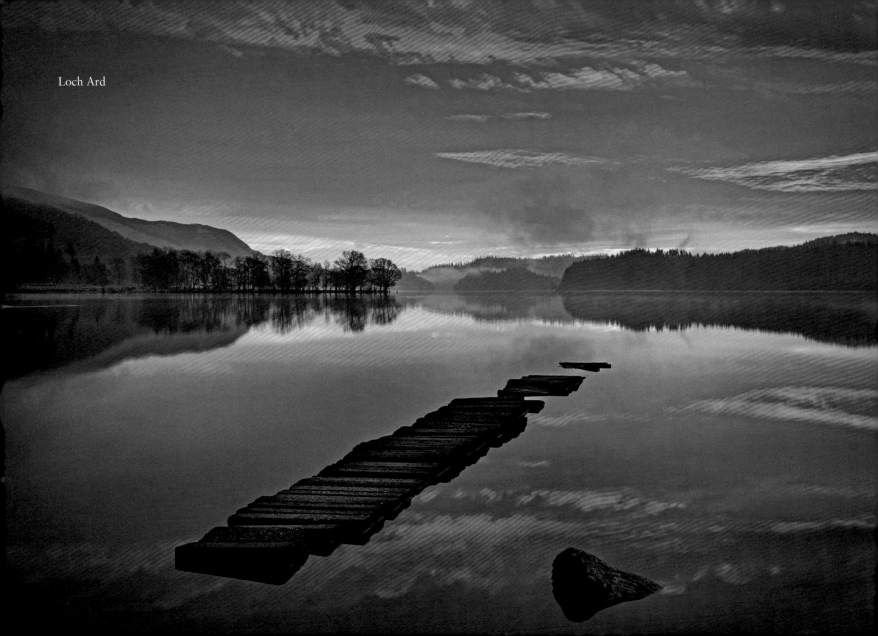

Loch Ard

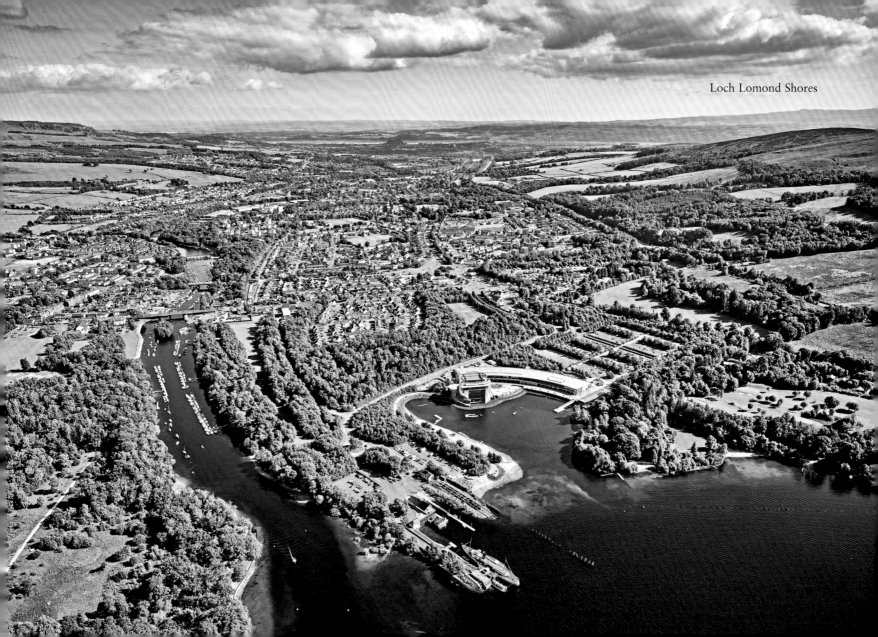

Loch Lomond Shores

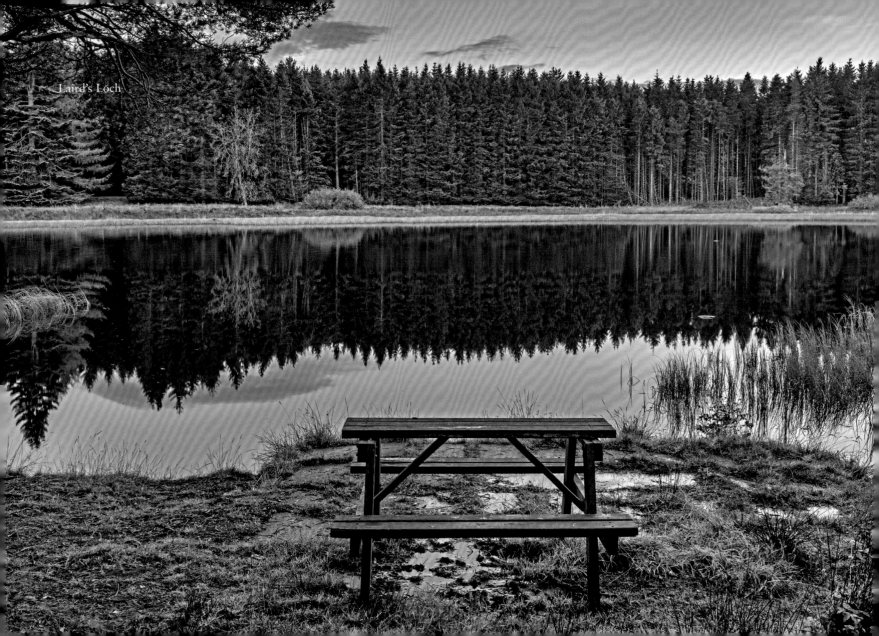

Laird's Loch

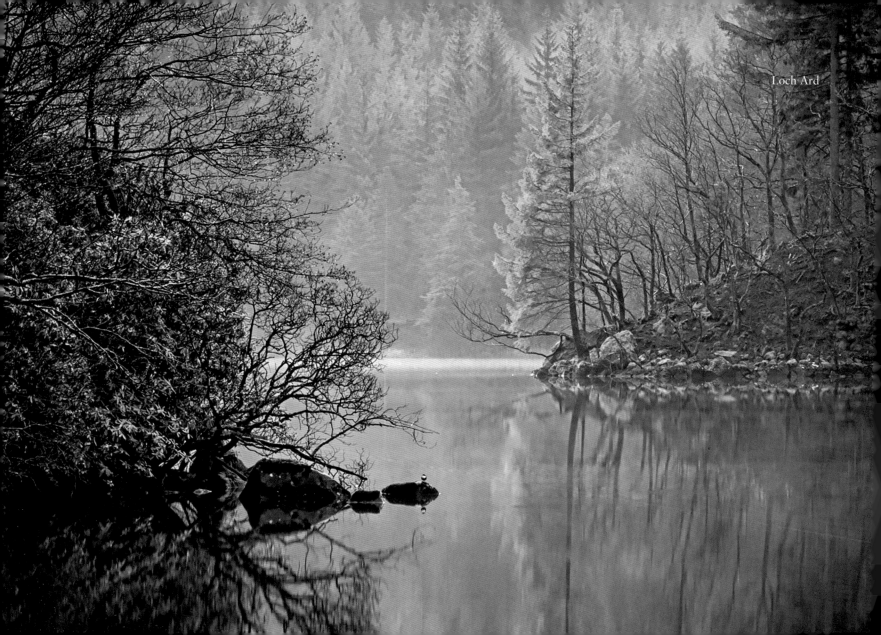

Loch Ard

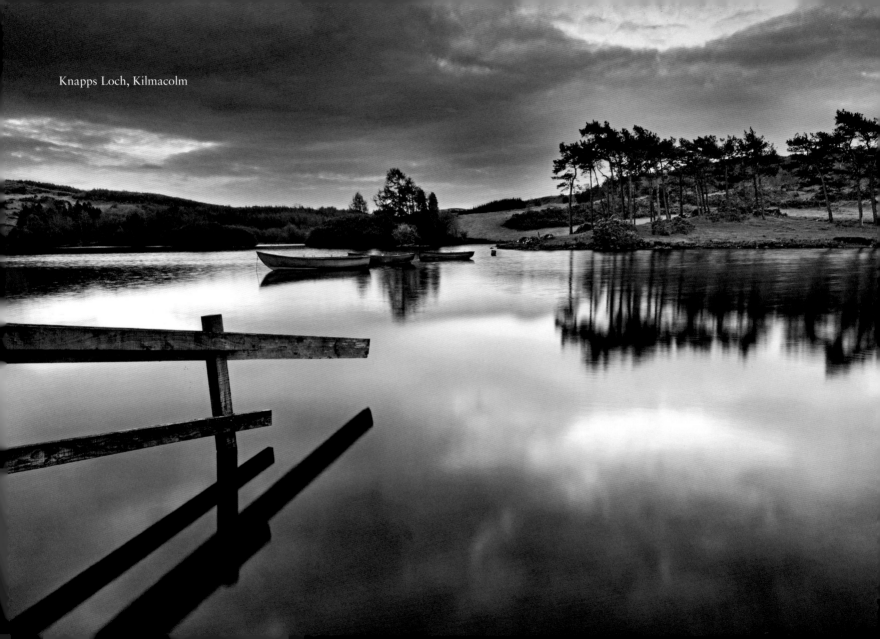

Knapps Loch, Kilmacolm

RIVERS & BRIDGES

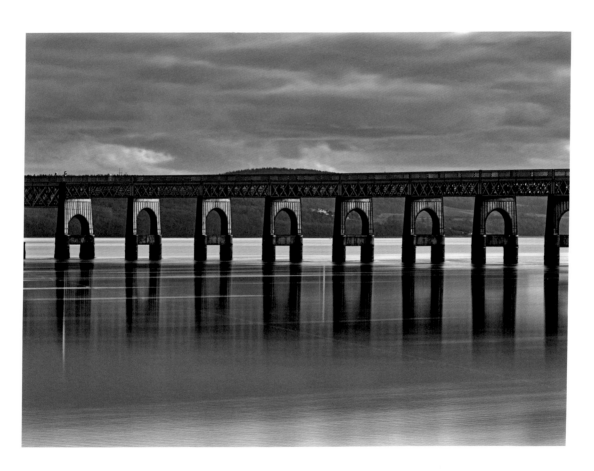

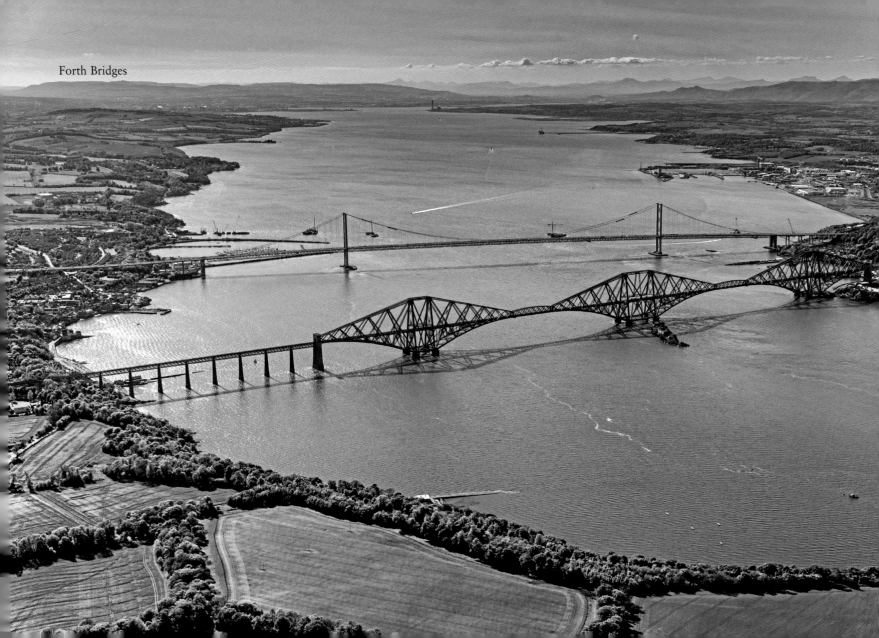

Forth Bridges

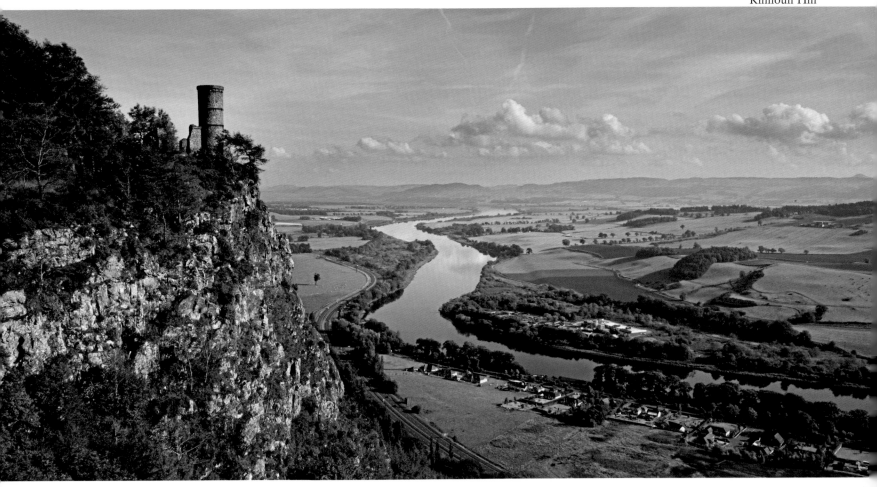

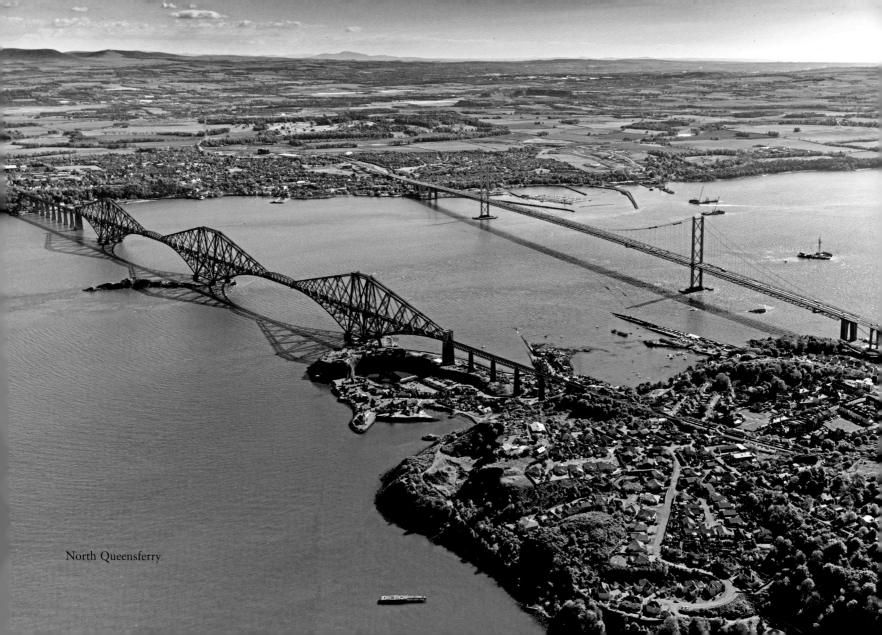

North Queensferry

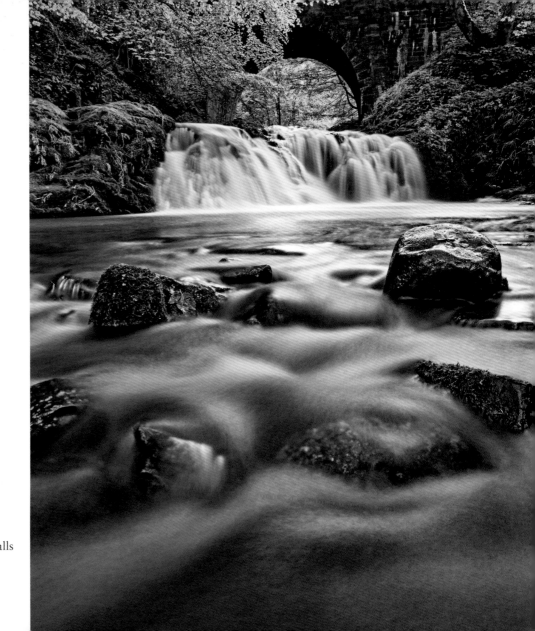

Arbirlot Falls

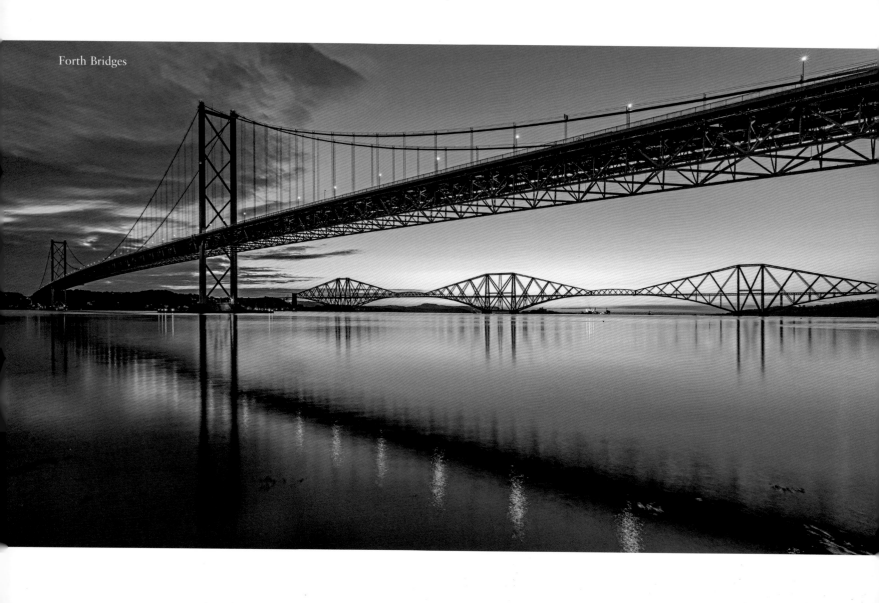

Forth Bridges

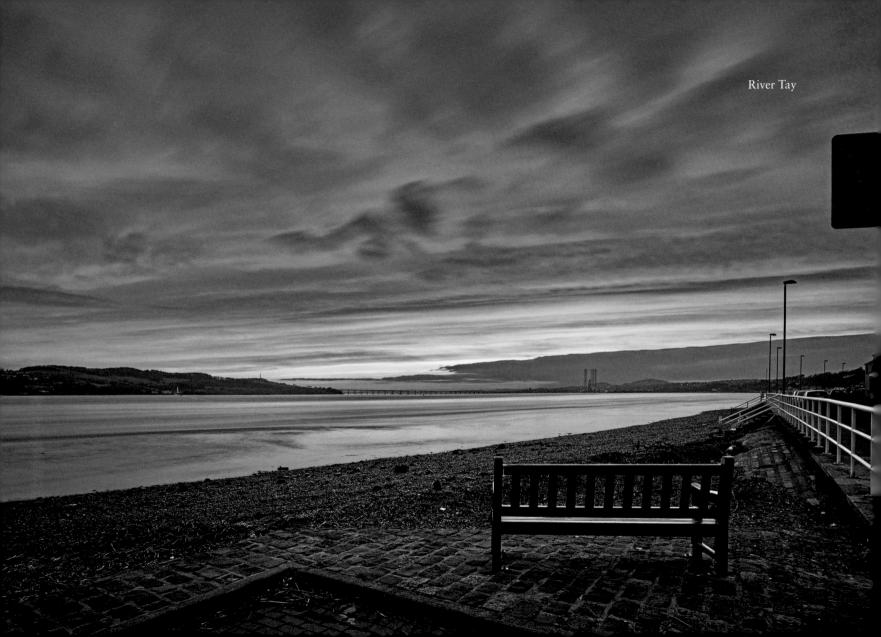

River Tay

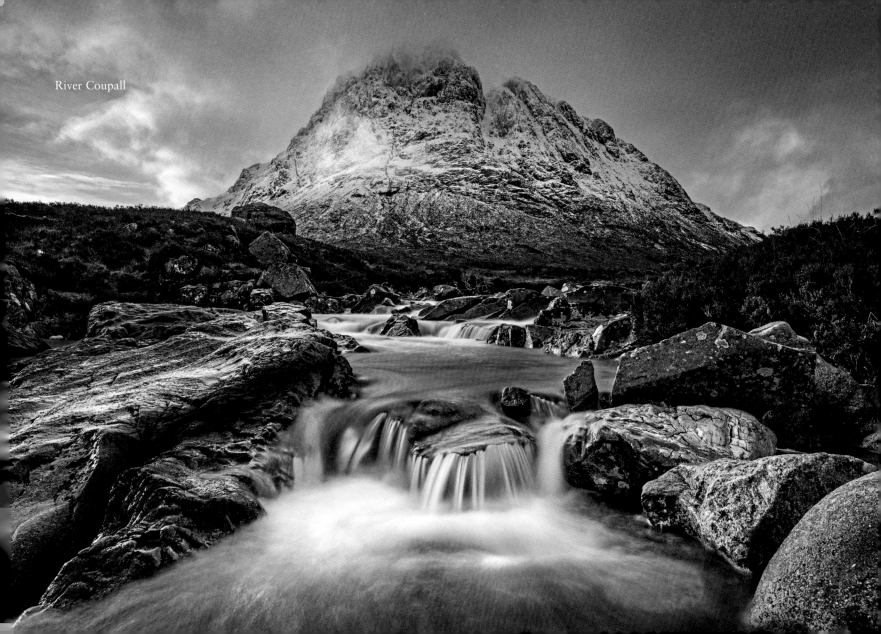

River Coupall

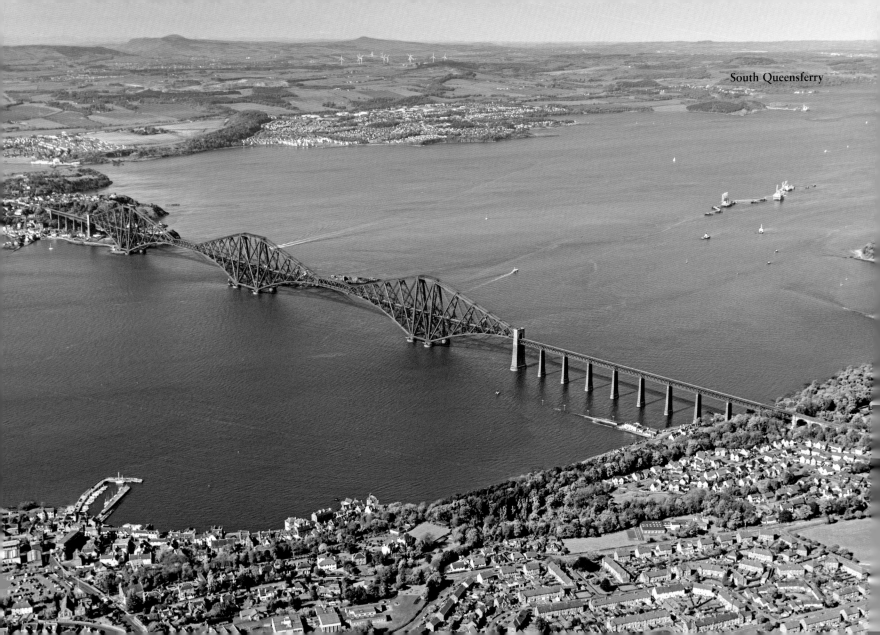

South Queensferry

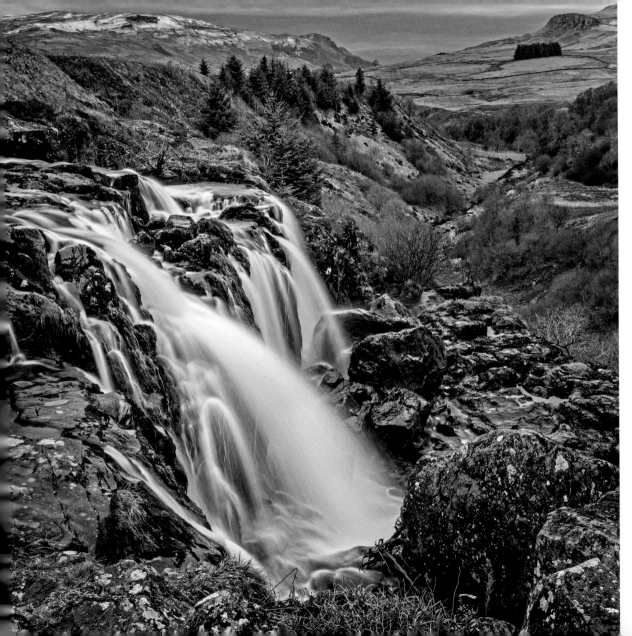

Loup of Fintry

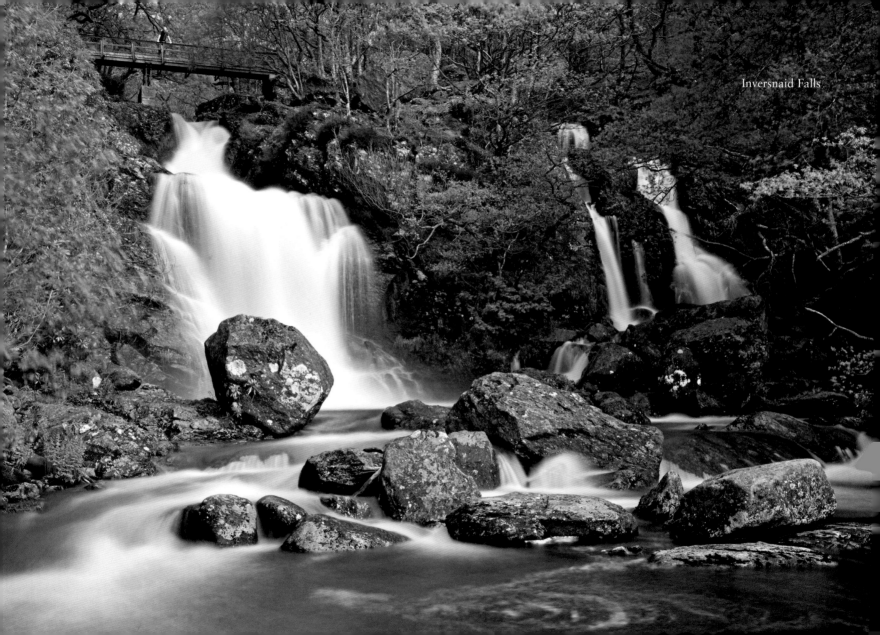

Inversnaid Falls

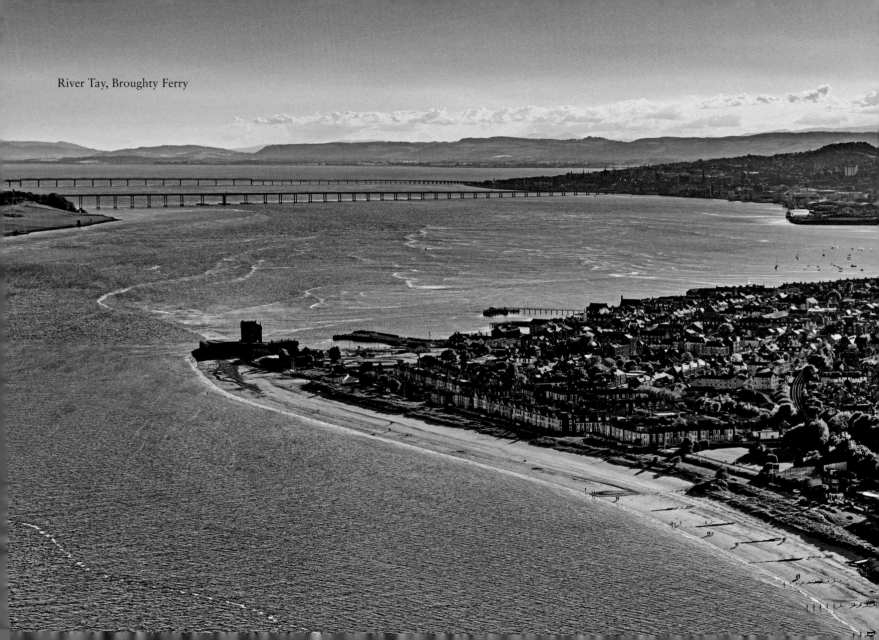

River Tay, Broughty Ferry

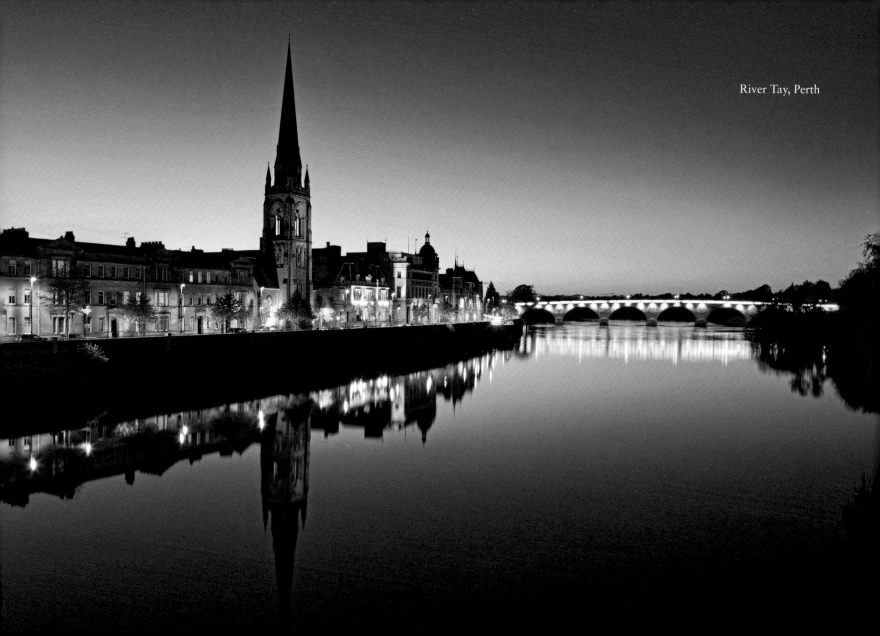

River Tay, Perth

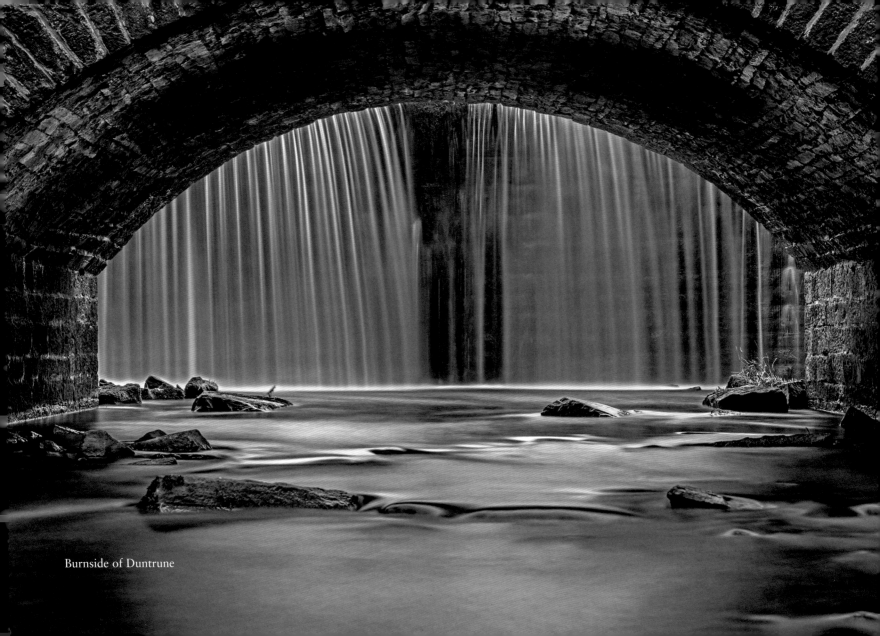

Burnside of Duntrune

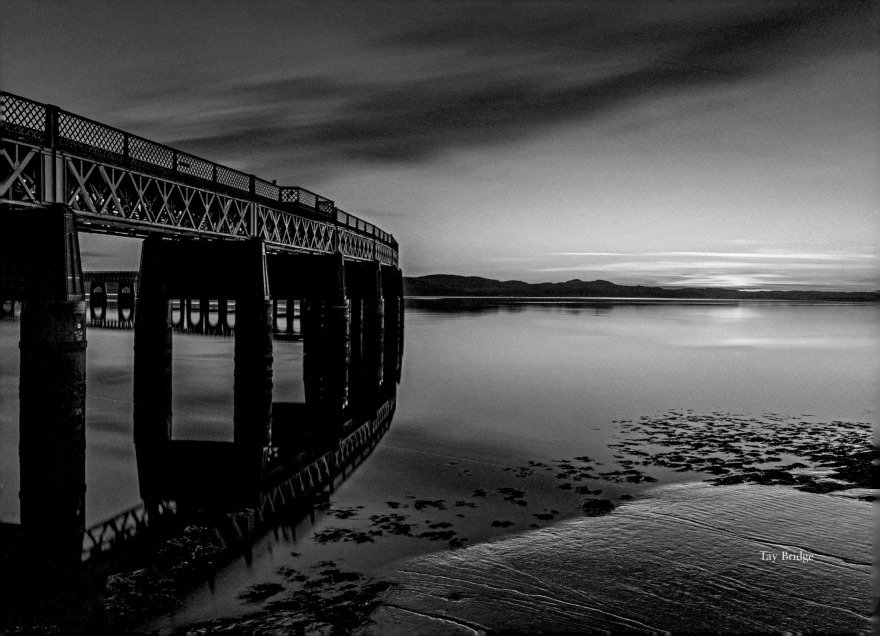

Tay Bridge

Hermitage, Dunkeld

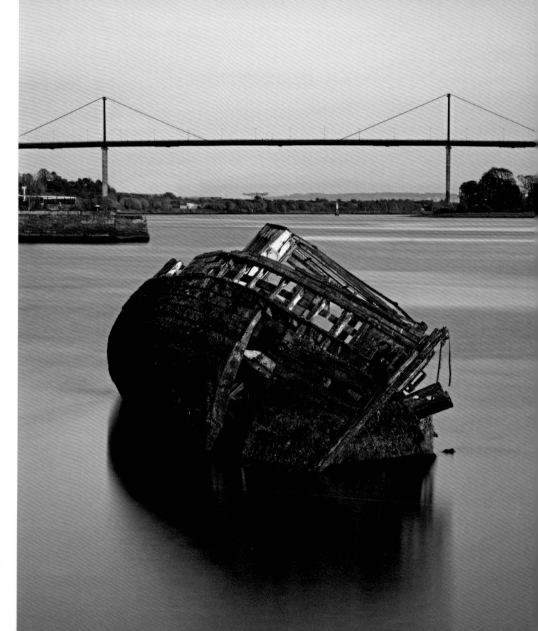

Bowling Harbour, Clydebank

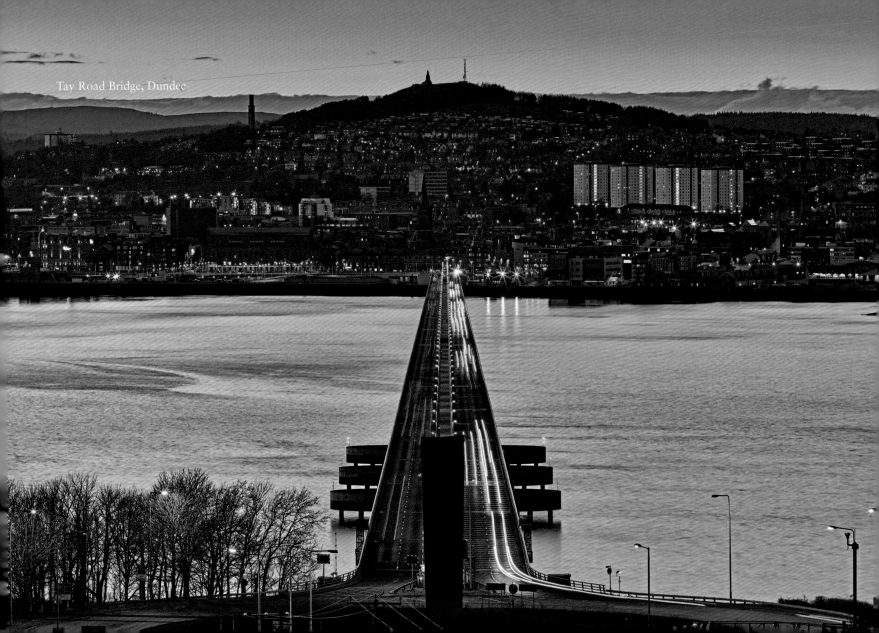

Tay Road Bridge, Dundee

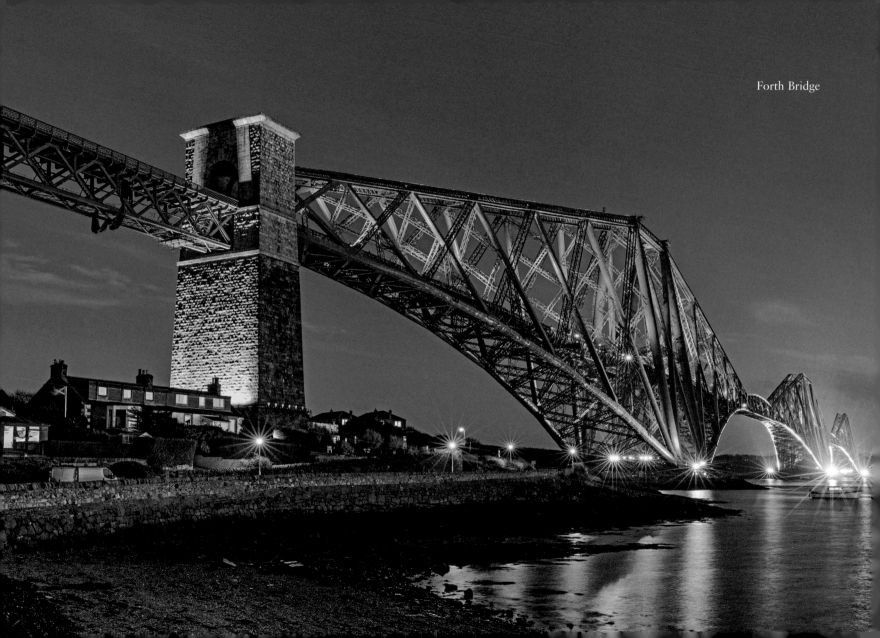

Forth Bridge

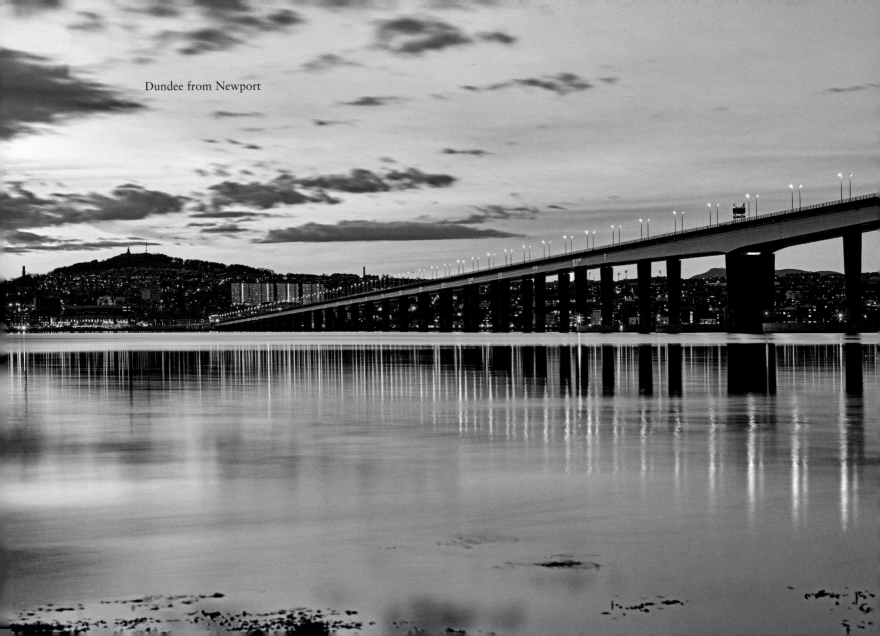

Dundee from Newport

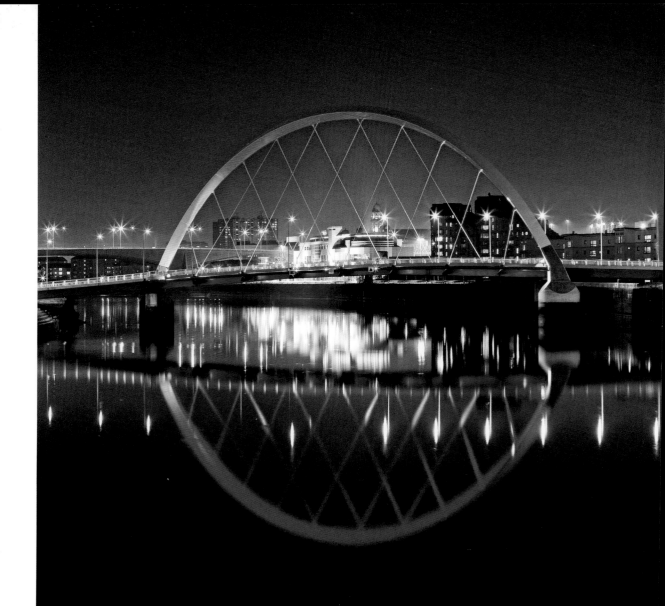

Clyde Bridge, Glasgow

BUILDINGS

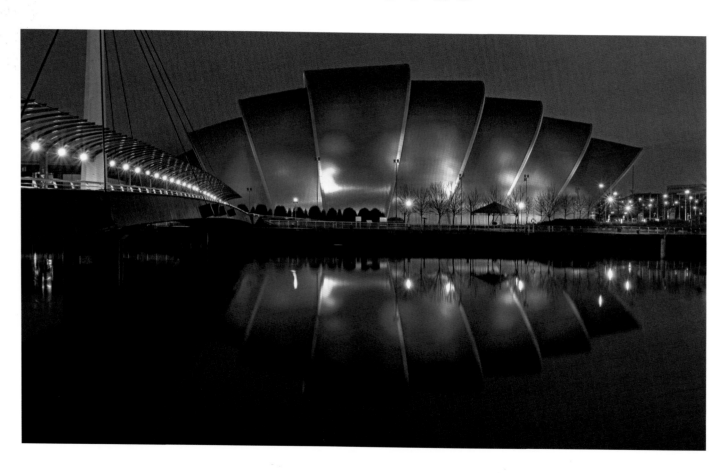

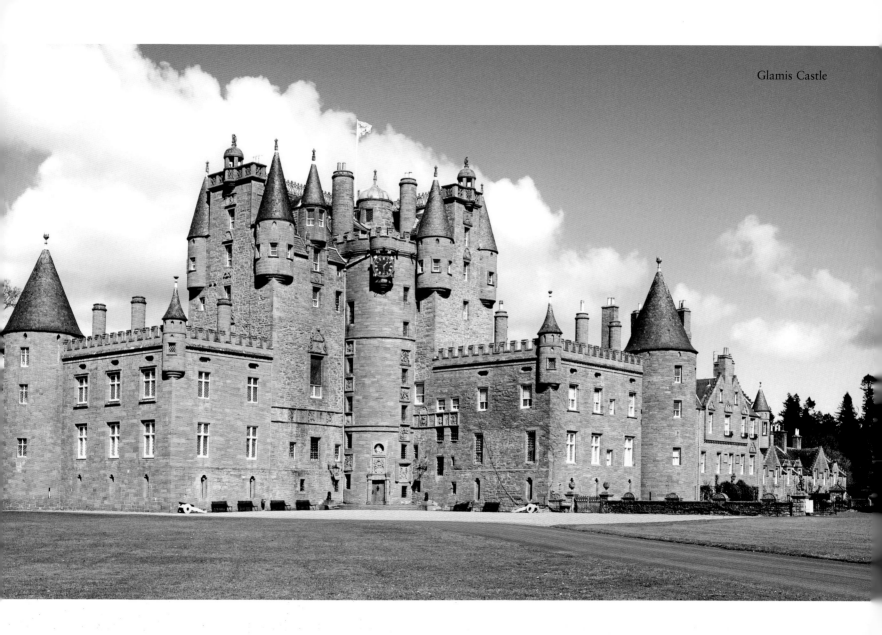

Glamis Castle

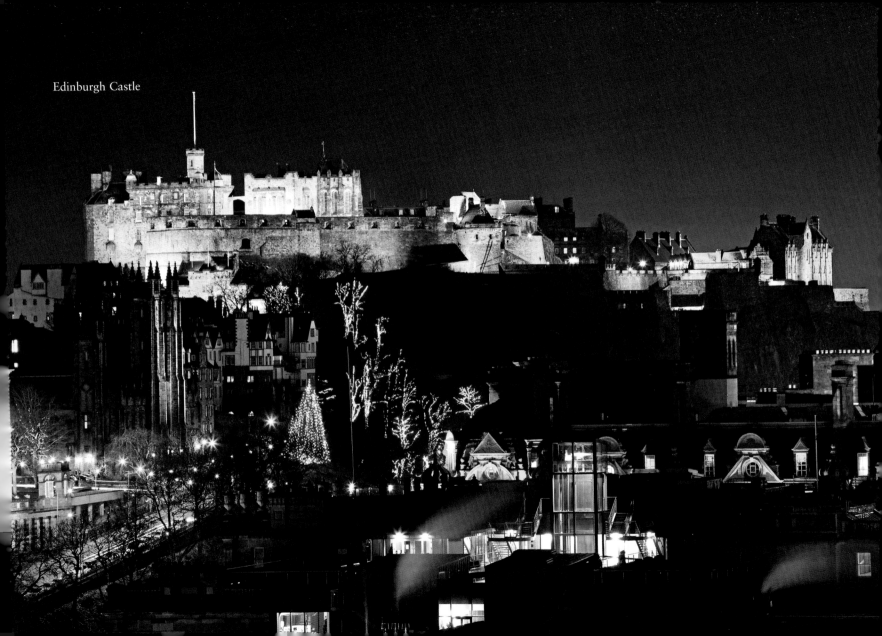

Edinburgh Castle

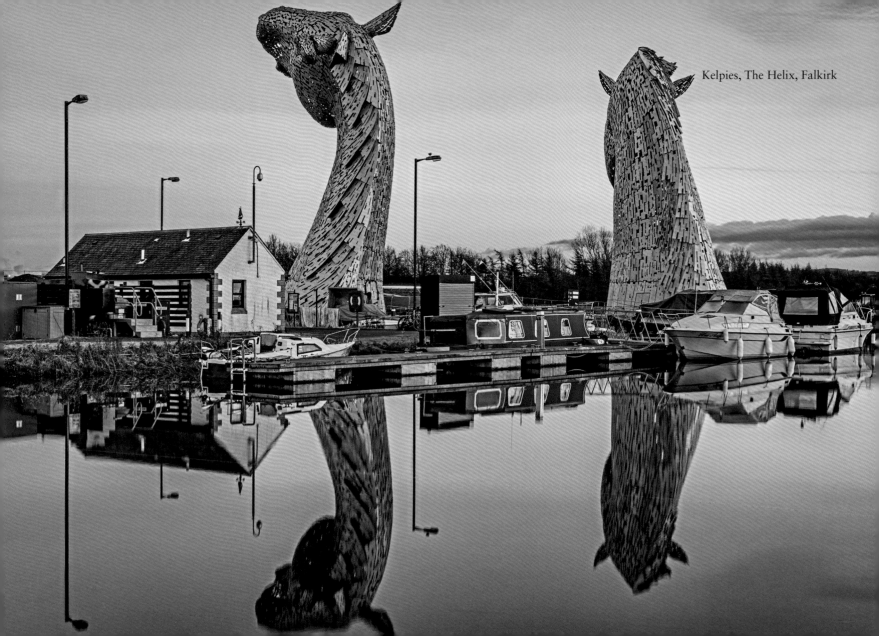

Kelpies, The Helix, Falkirk

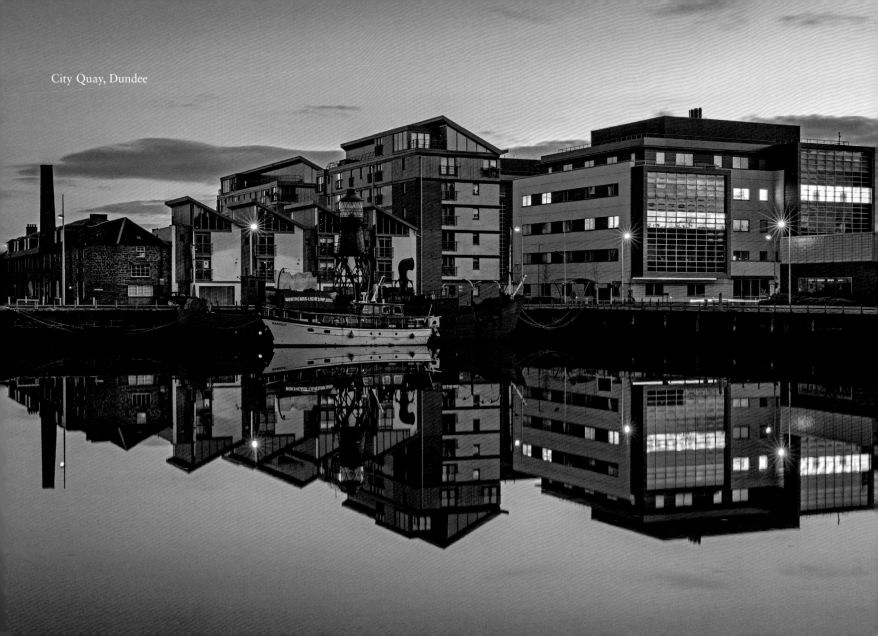

City Quay, Dundee

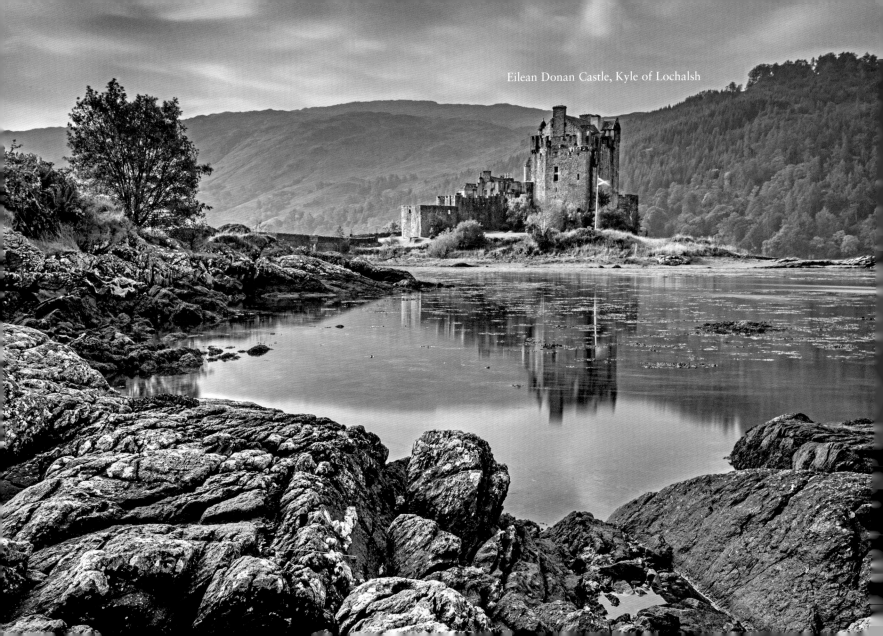
Eilean Donan Castle, Kyle of Lochalsh

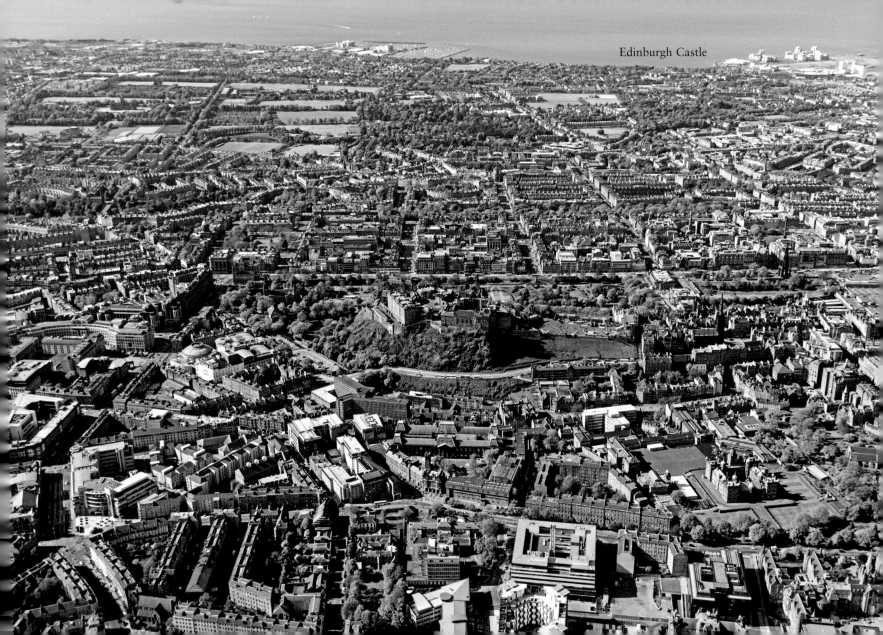

Edinburgh Castle

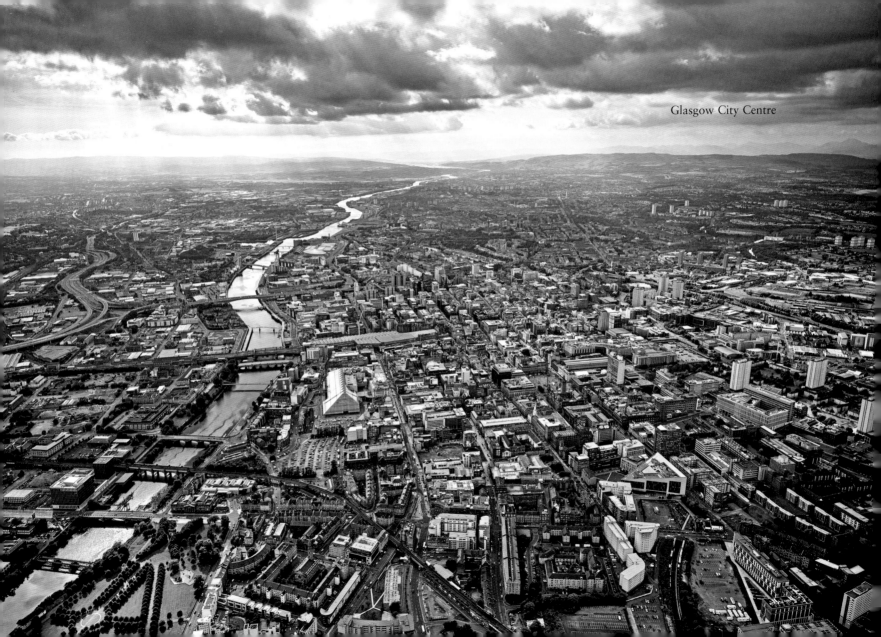

Glasgow City Centre

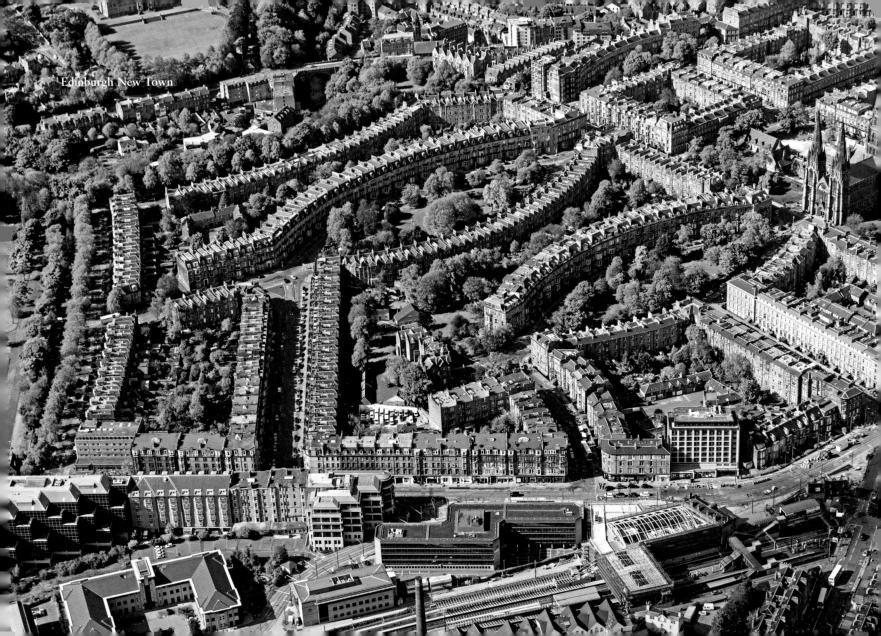

Edinburgh New Town

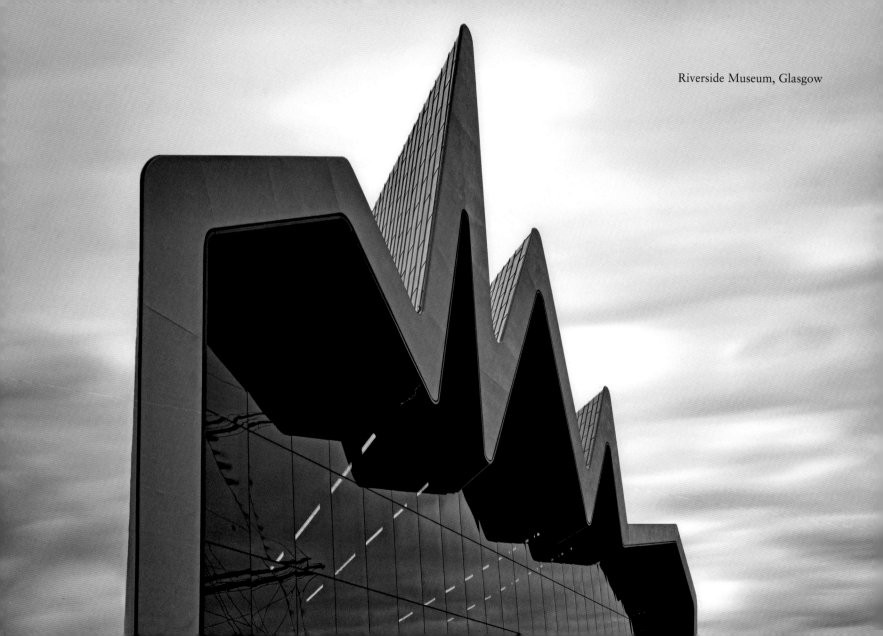

Riverside Museum, Glasgow

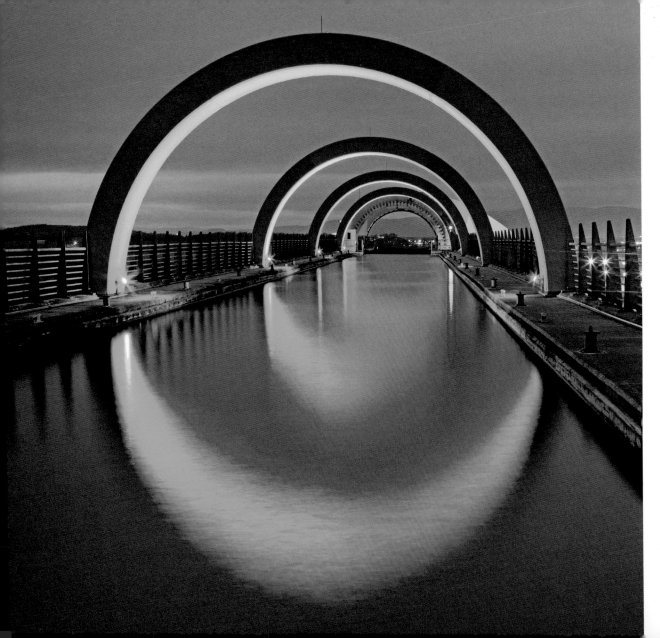

Falkirk Wheel

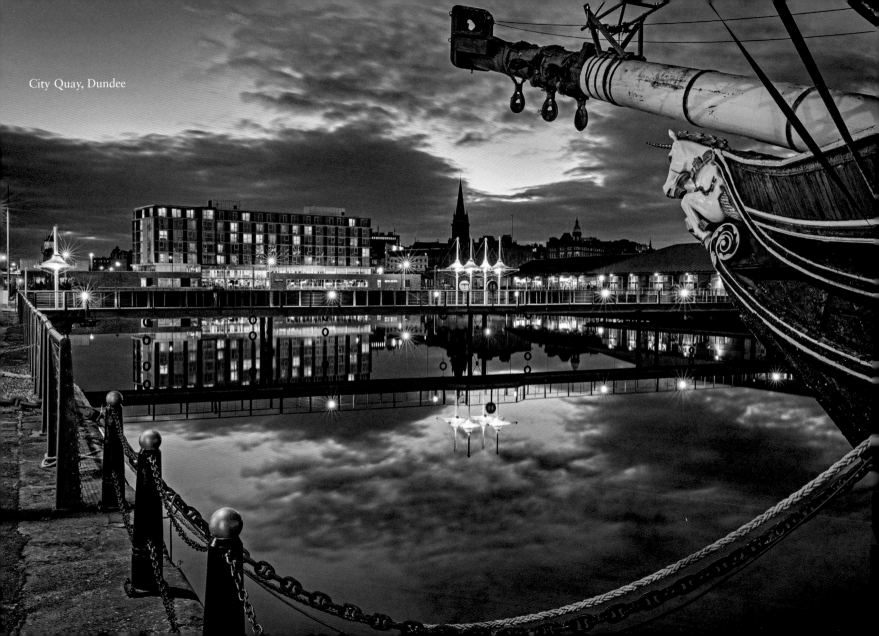

City Quay, Dundee

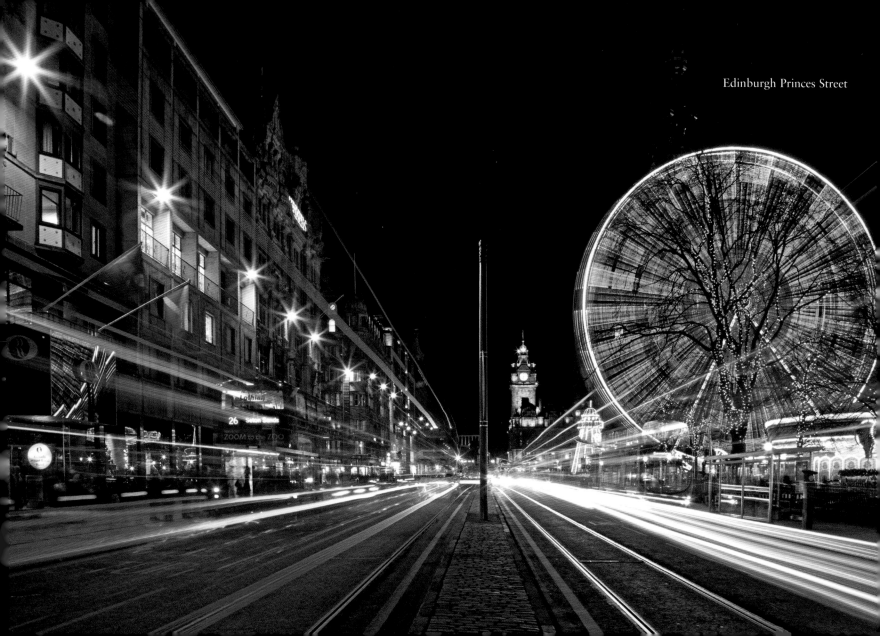

Edinburgh Princes Street

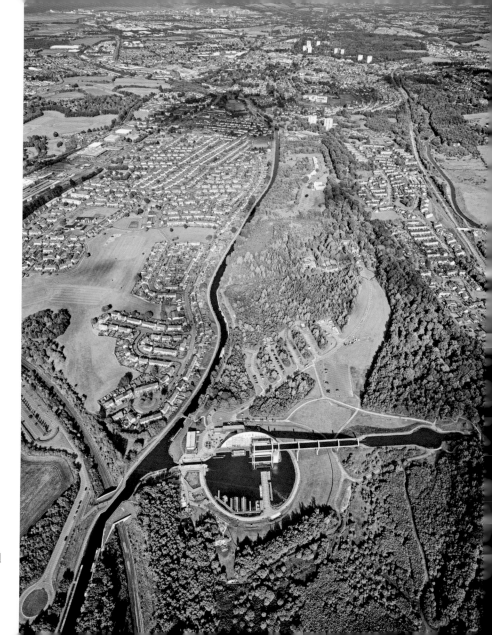

Falkirk Wheel

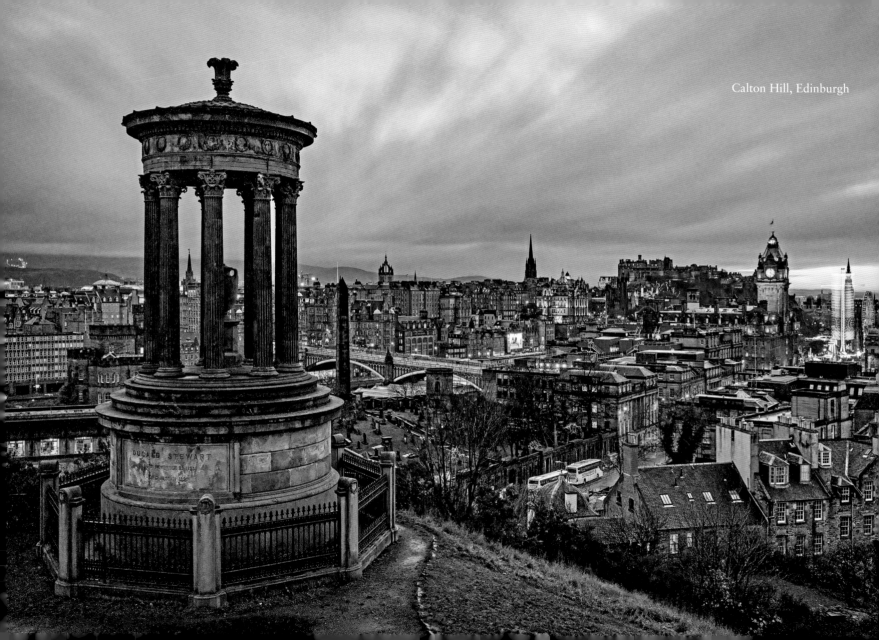

Calton Hill, Edinburgh

MOUNTAINS, GLENS & FORESTS

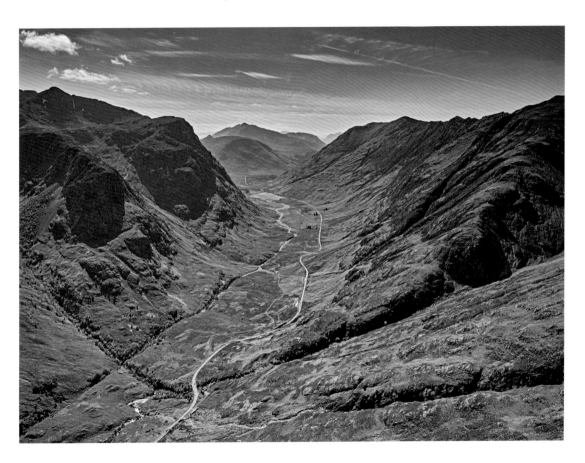

Glenfinnan

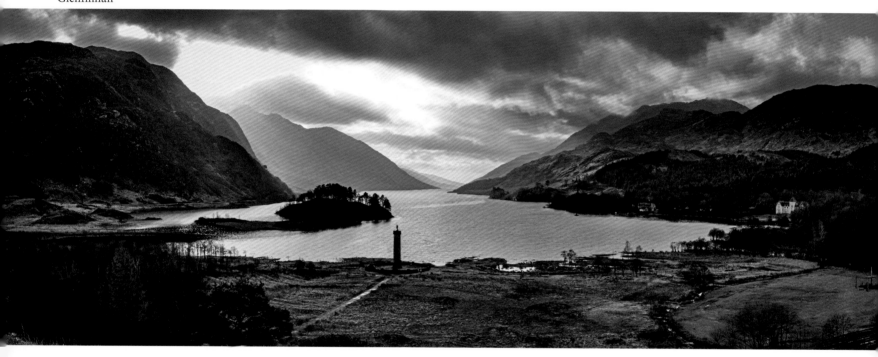

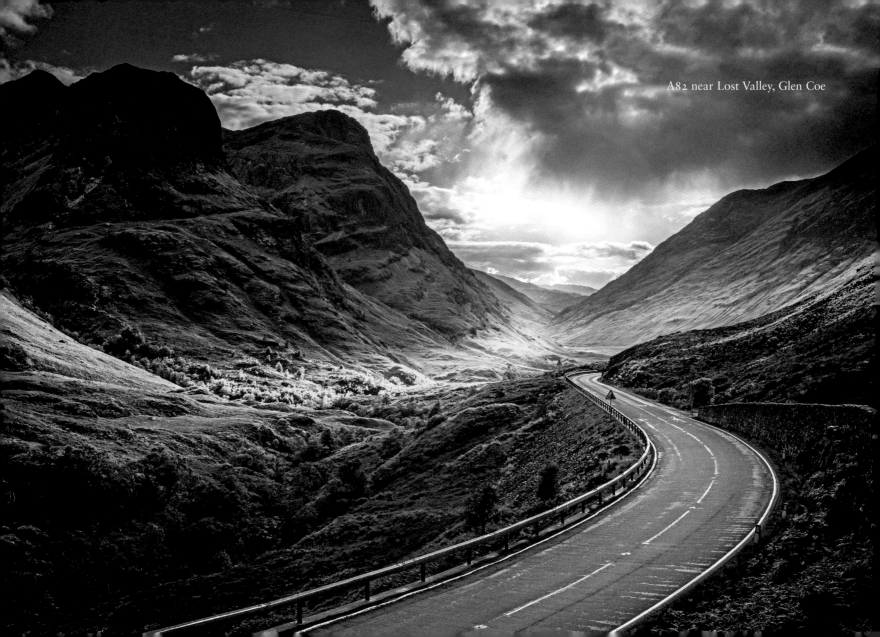

A82 near Lost Valley, Glen Coe

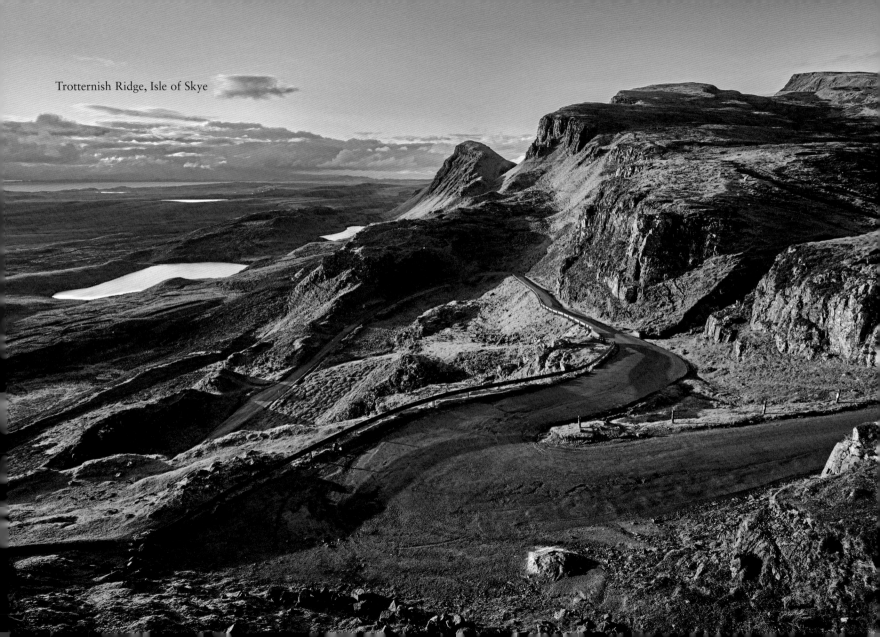

Trotternish Ridge, Isle of Skye

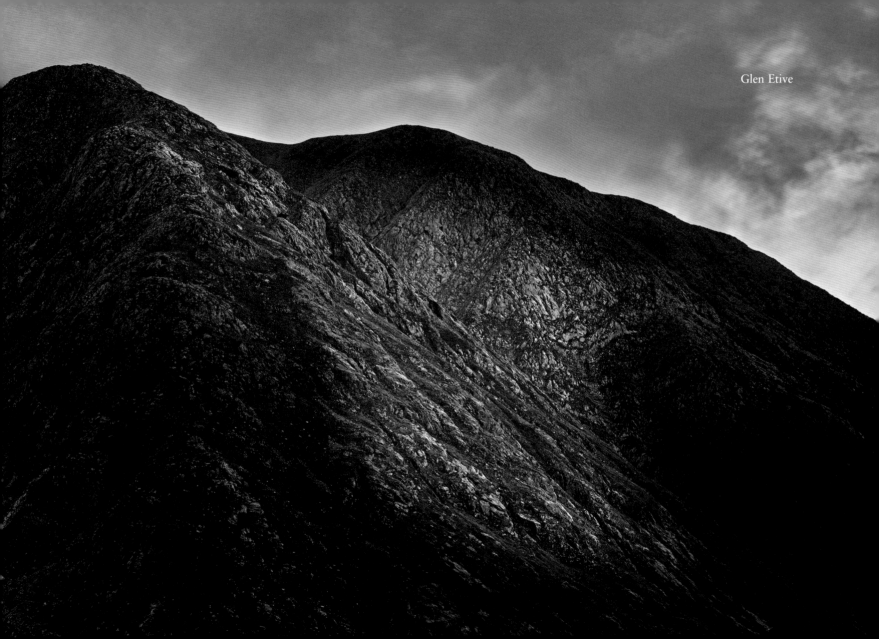

Glen Etive

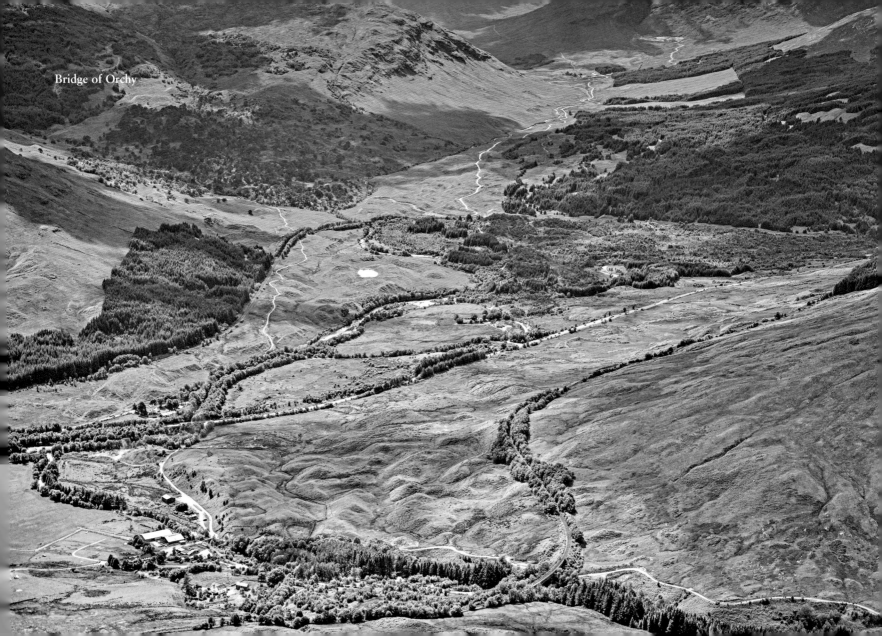

Bridge of Orchy

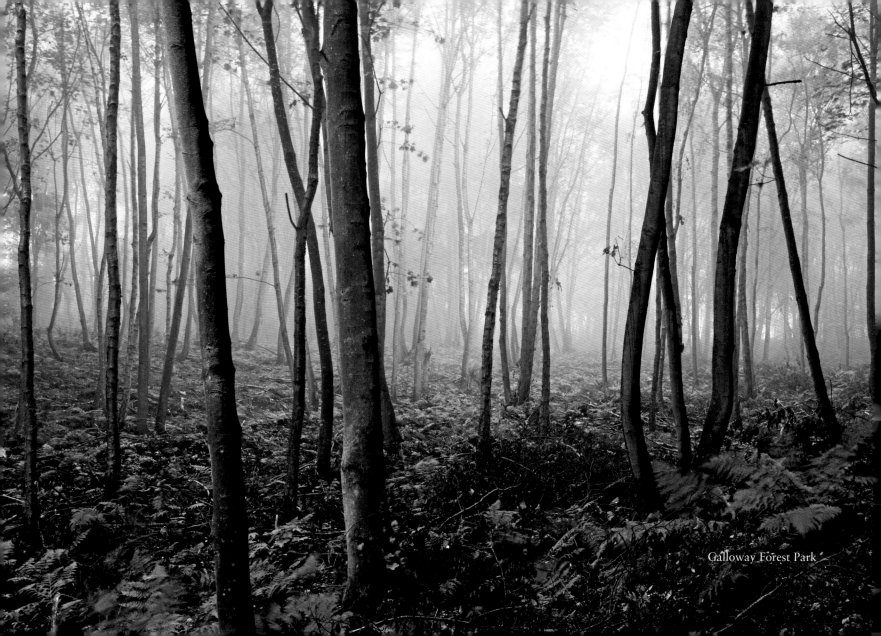

Galloway Forest Park

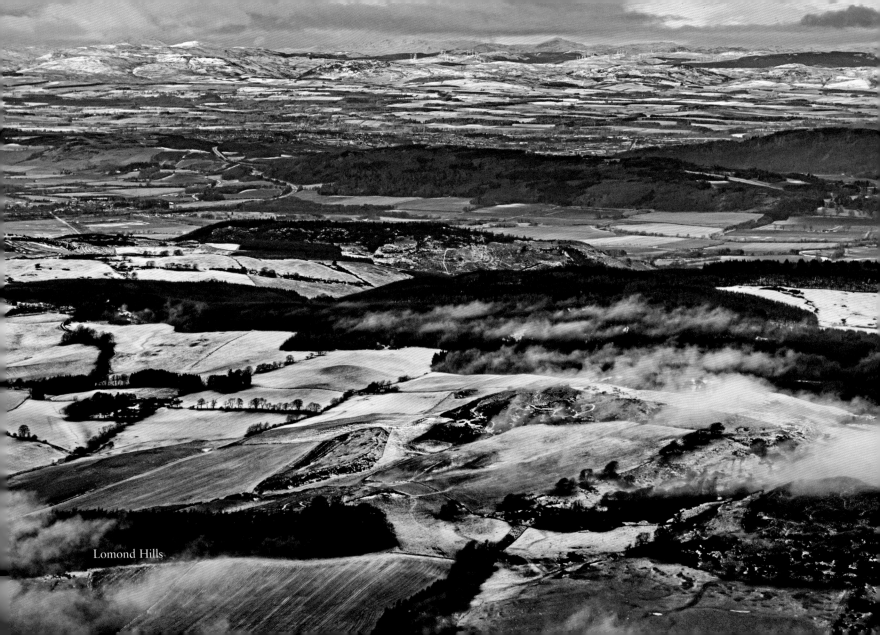

Lomond Hills

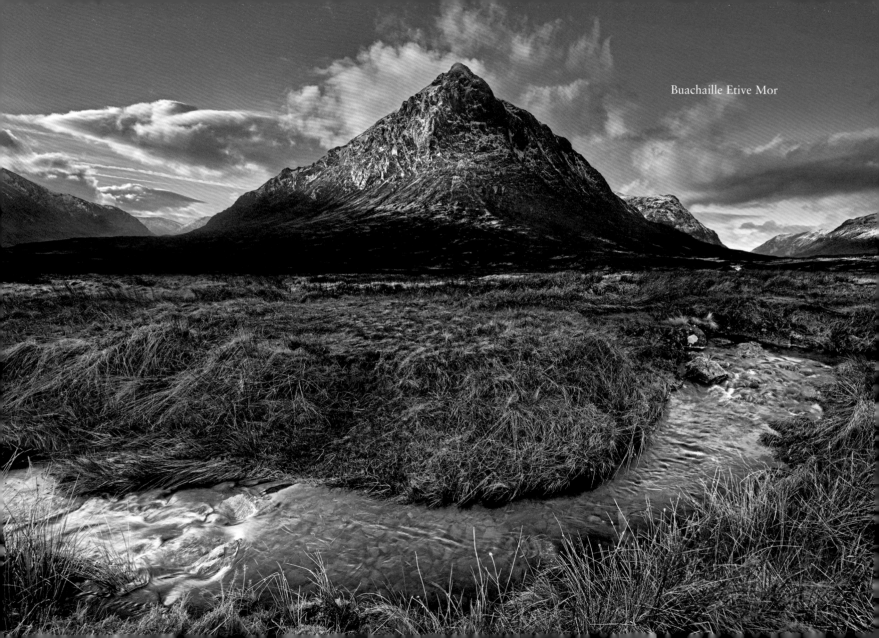

Buachaille Etive Mor

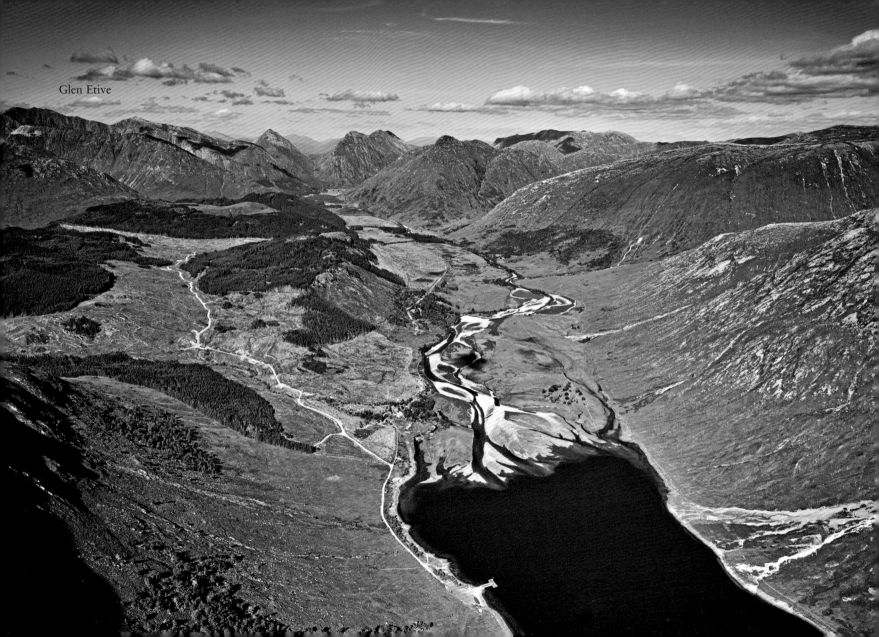

Glen Etive

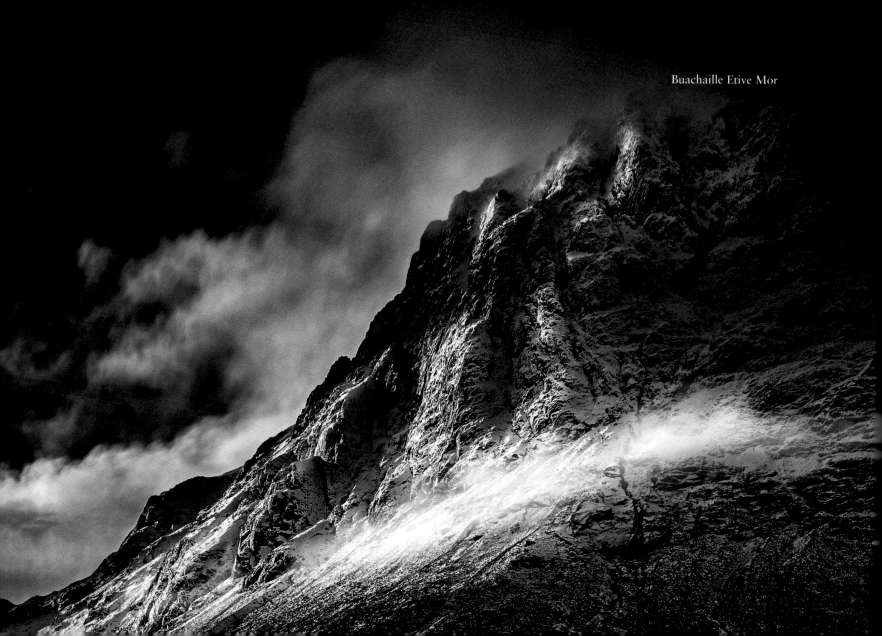

Buachaille Etive Mor

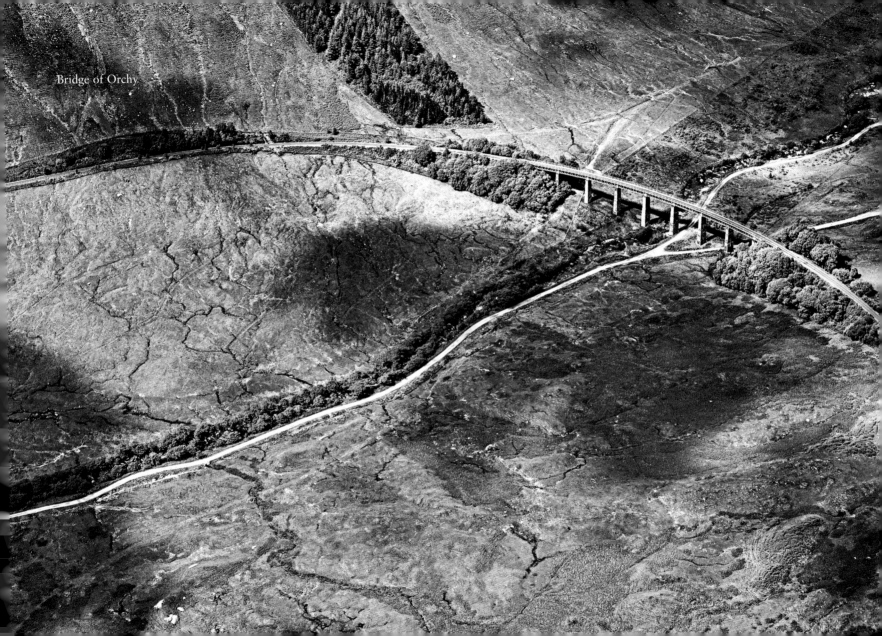

Bridge of Orchy

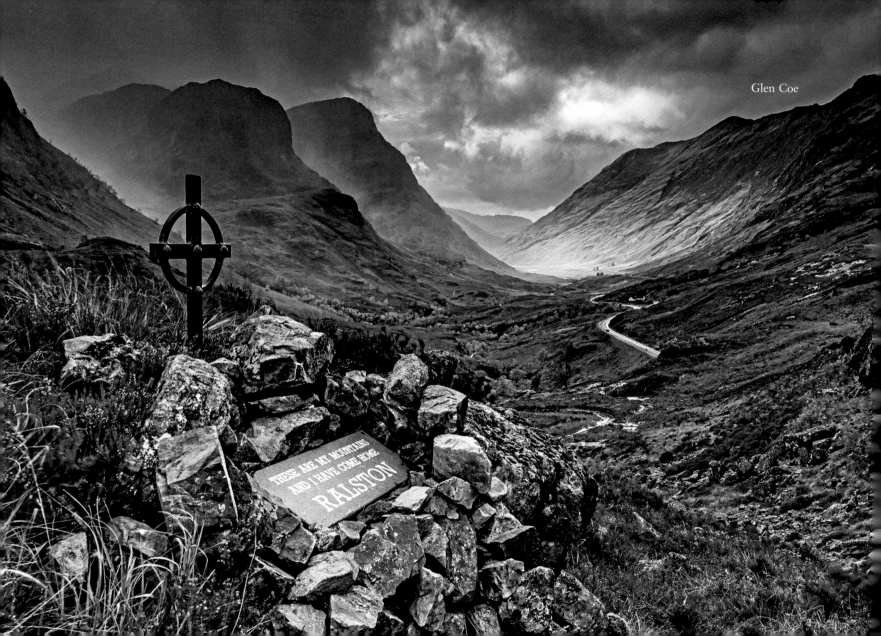

Glen Coe

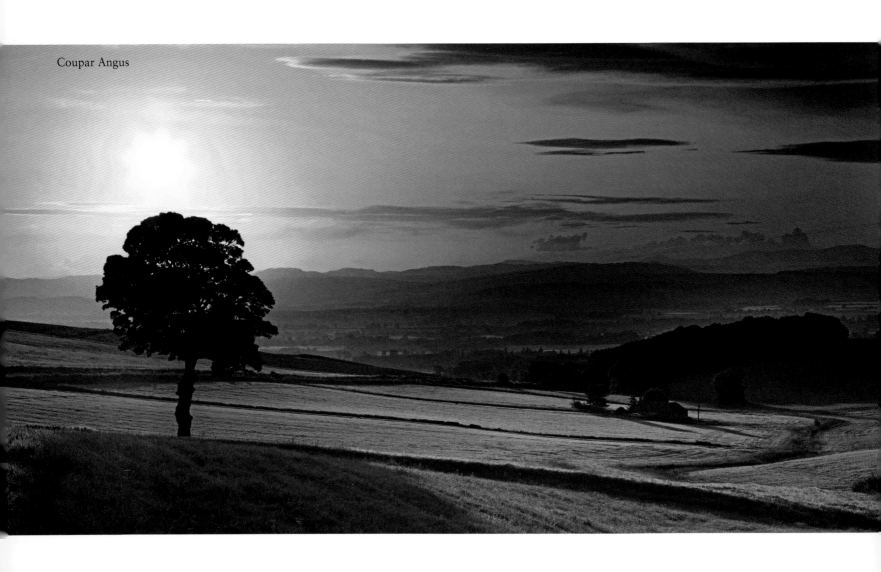

Coupar Angus

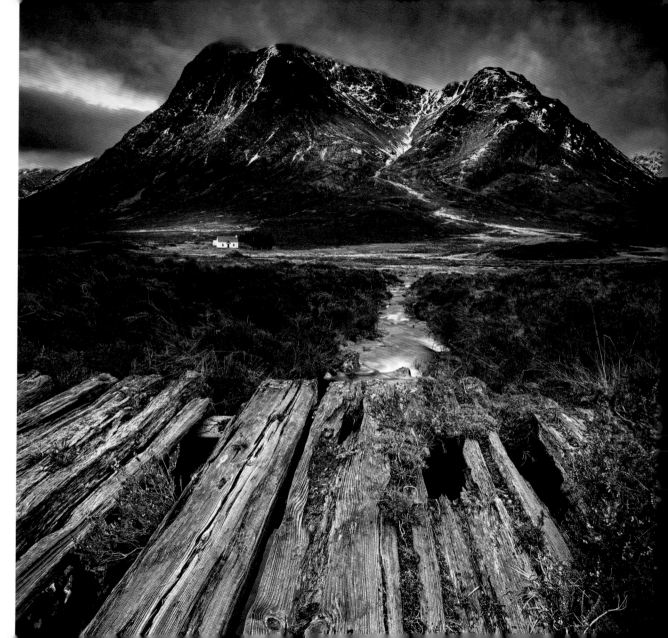

Lagangarbh, Glen Coe

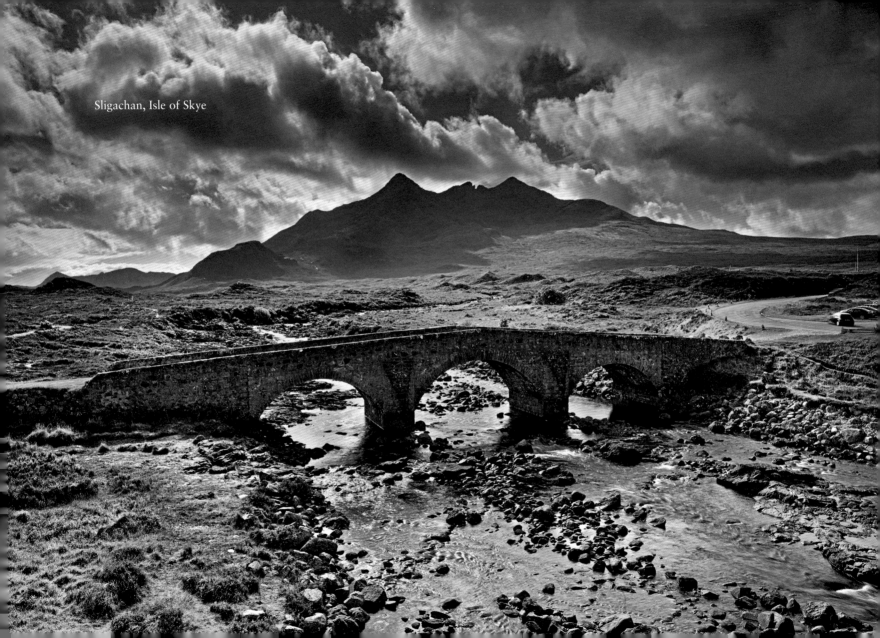

Sligachan, Isle of Skye

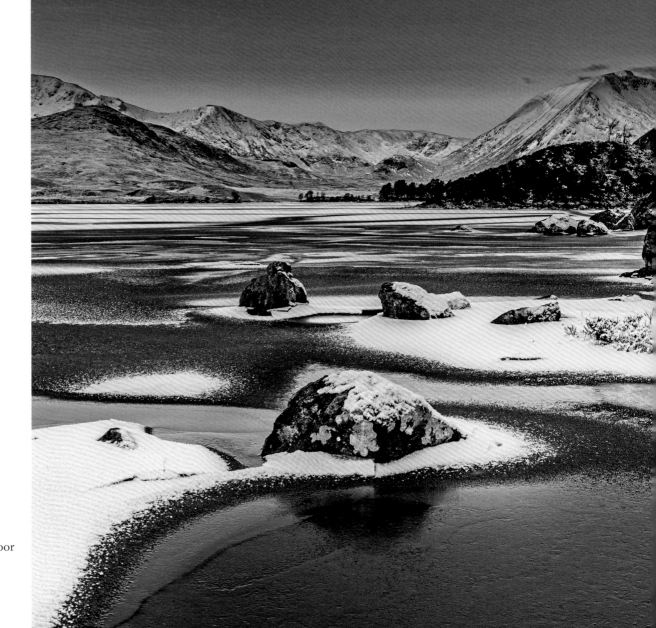

Rannoch Moor

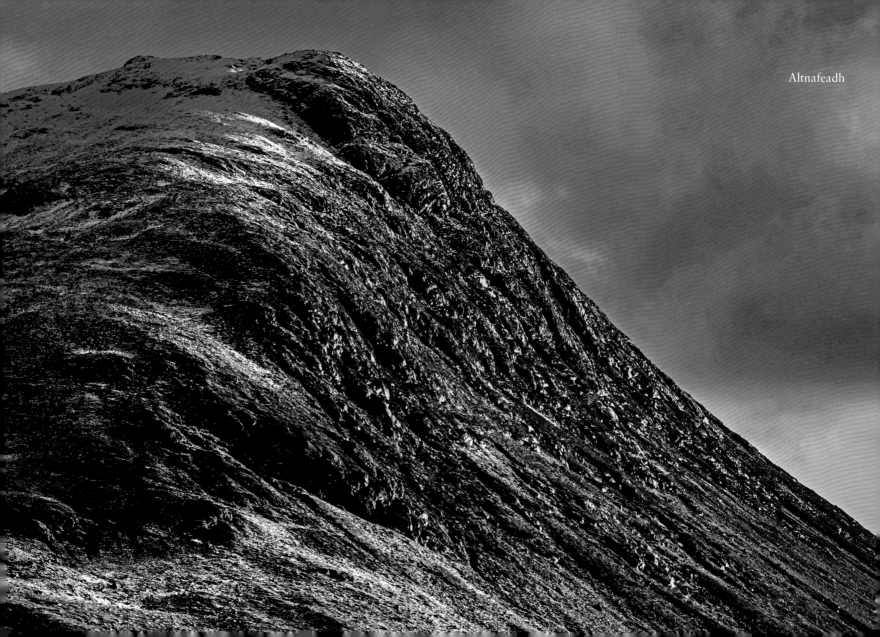

Altnafeadh

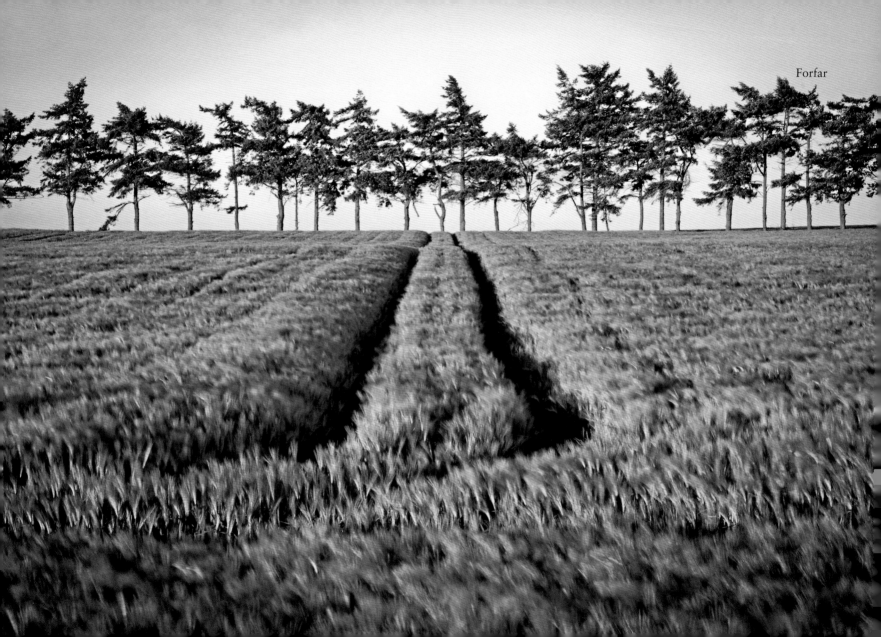

Forfar

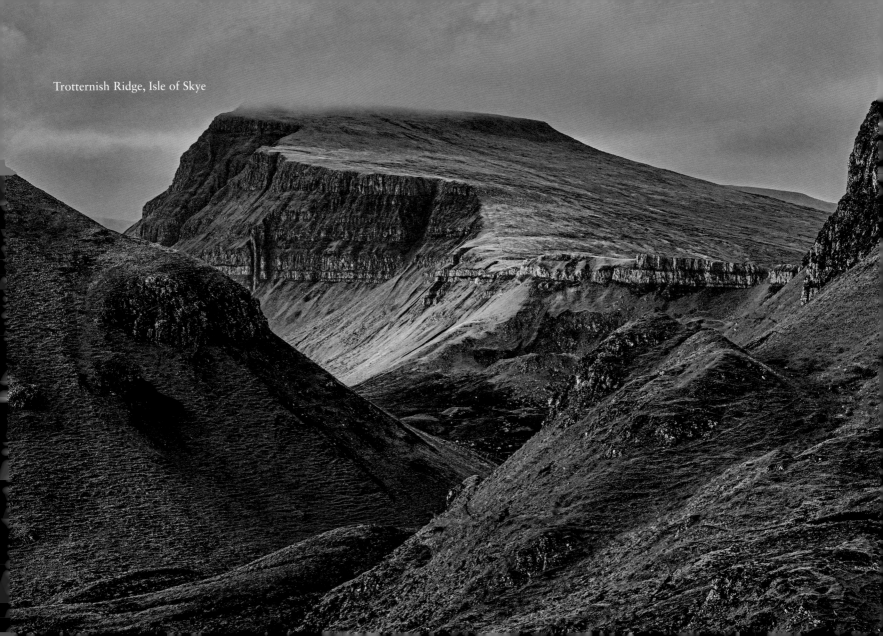
Trotternish Ridge, Isle of Skye

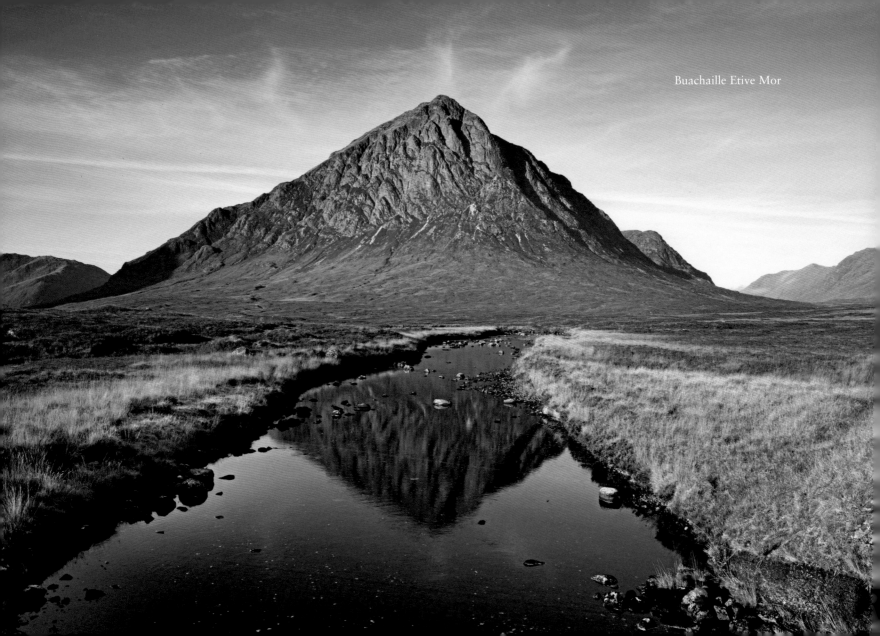

Buachaille Etive Mor

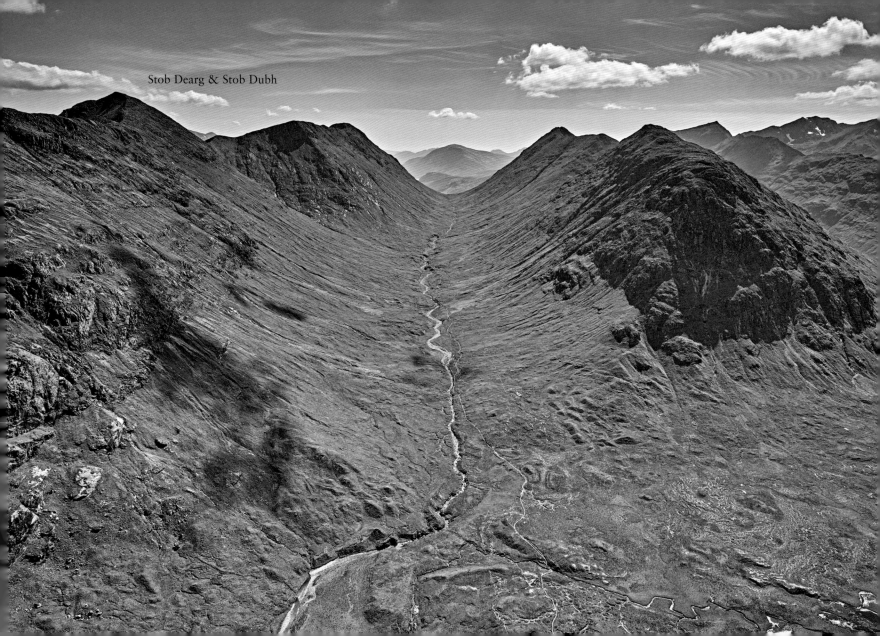

Stob Dearg & Stob Dubh

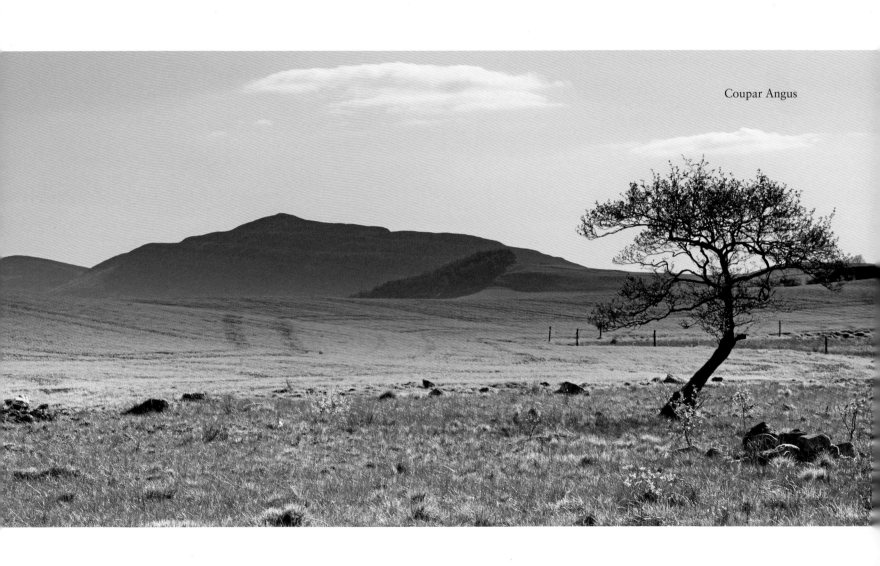

Coupar Angus

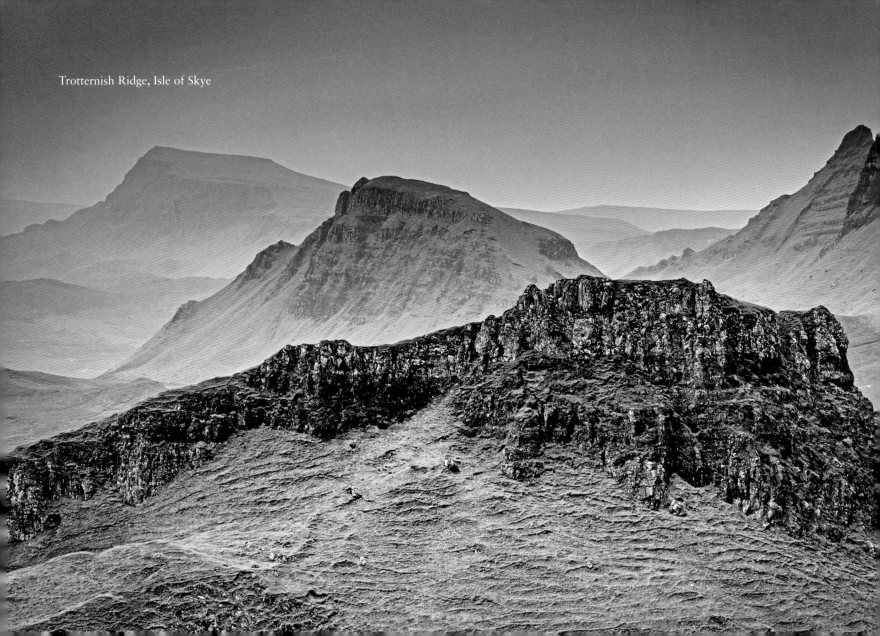

Trotternish Ridge, Isle of Skye

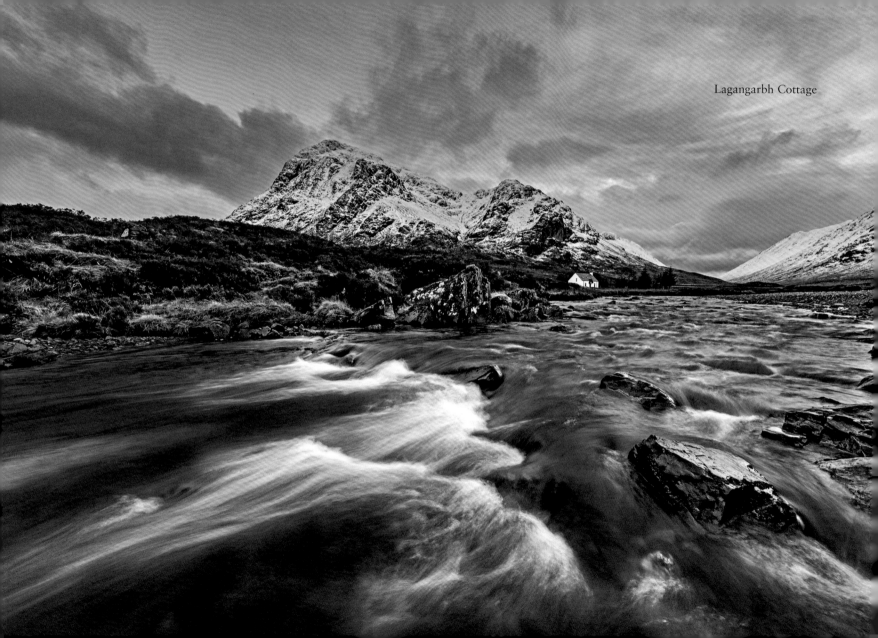

Lagangarbh Cottage

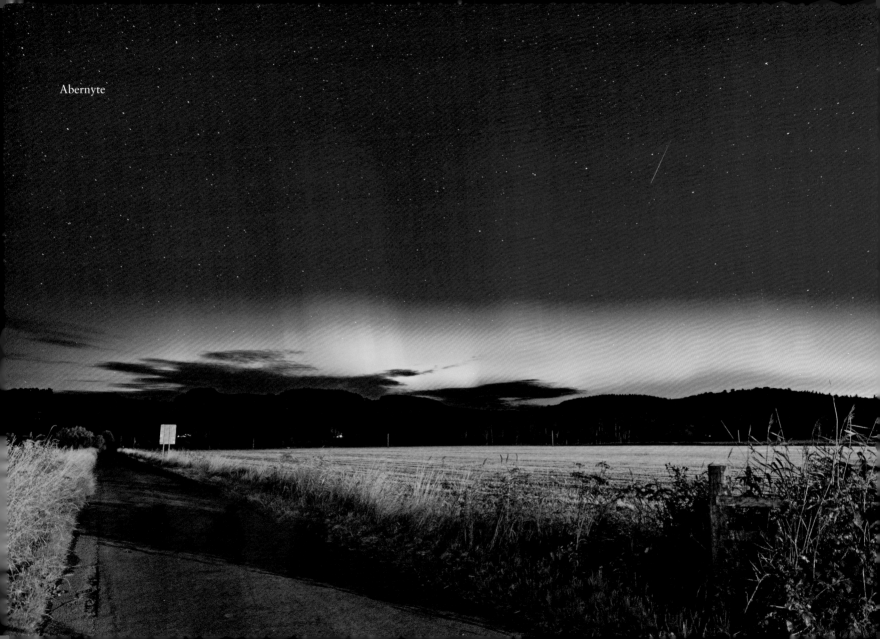

Abernyte

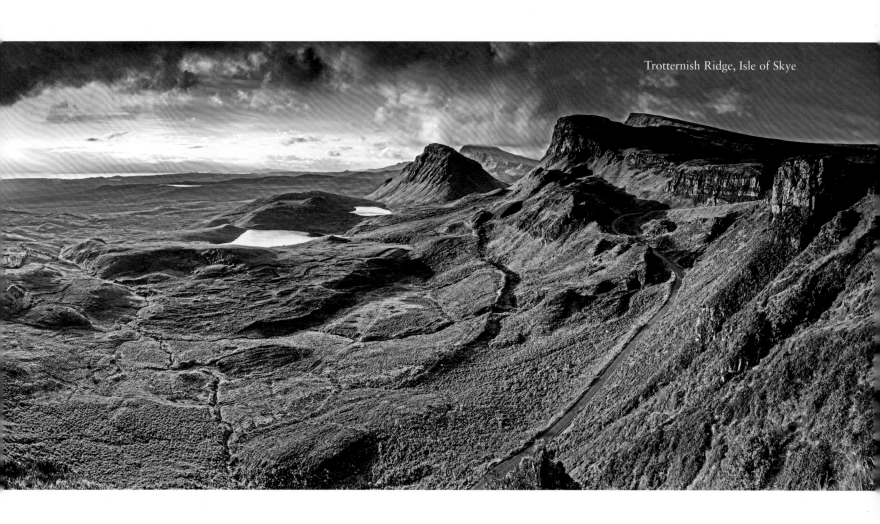

Trotternish Ridge, Isle of Skye

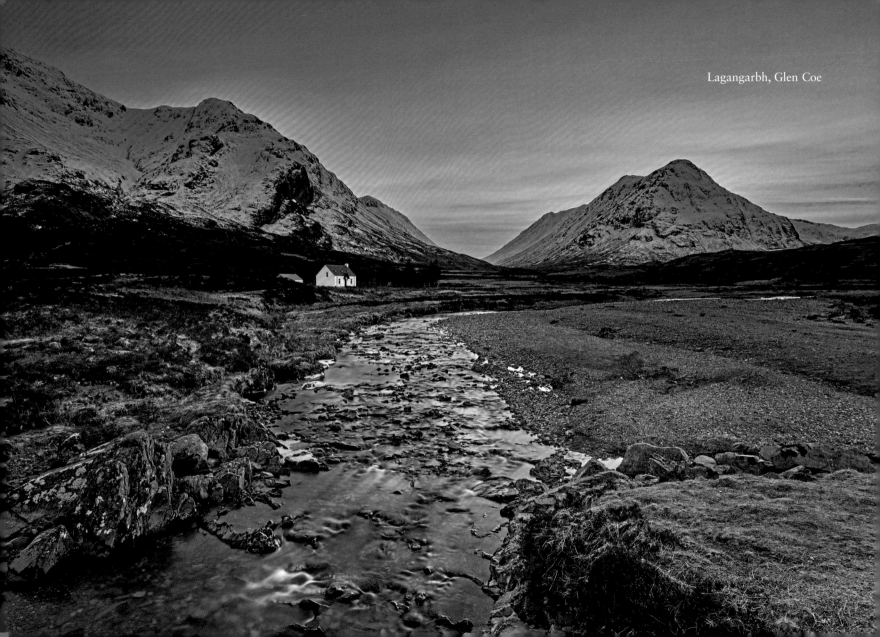
Lagangarbh, Glen Coe

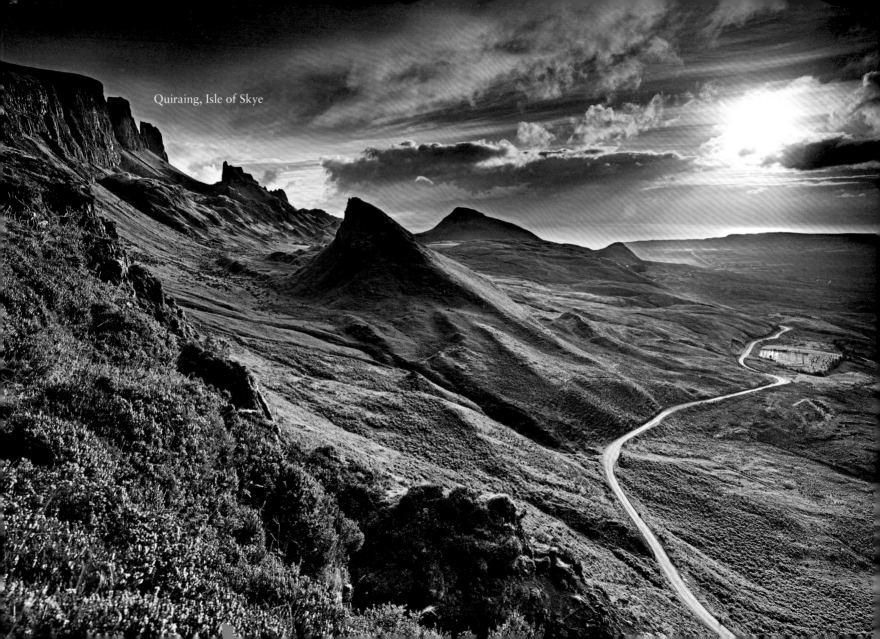

Quiraing, Isle of Skye

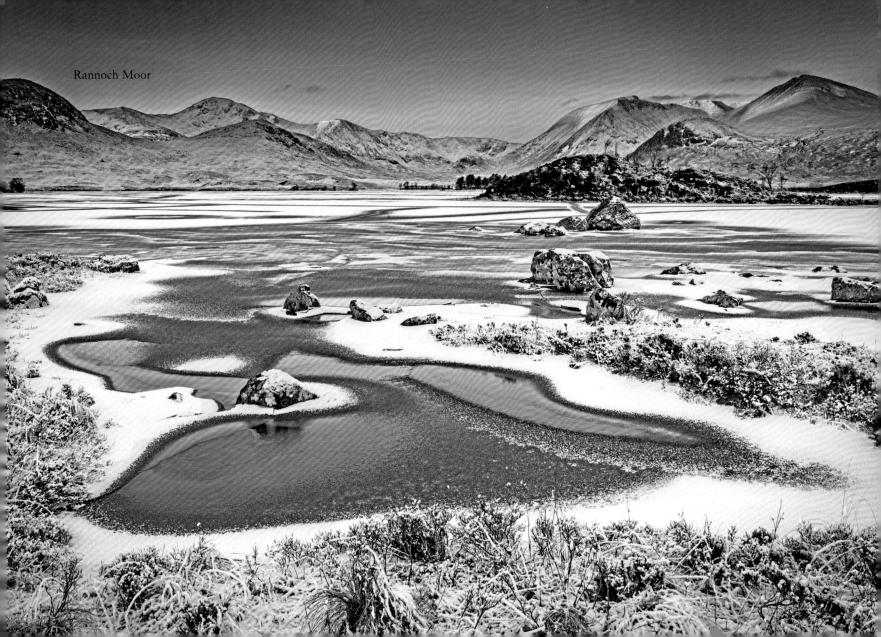
Rannoch Moor